Harry Potter™

FILM VAULT

VOLUME 11

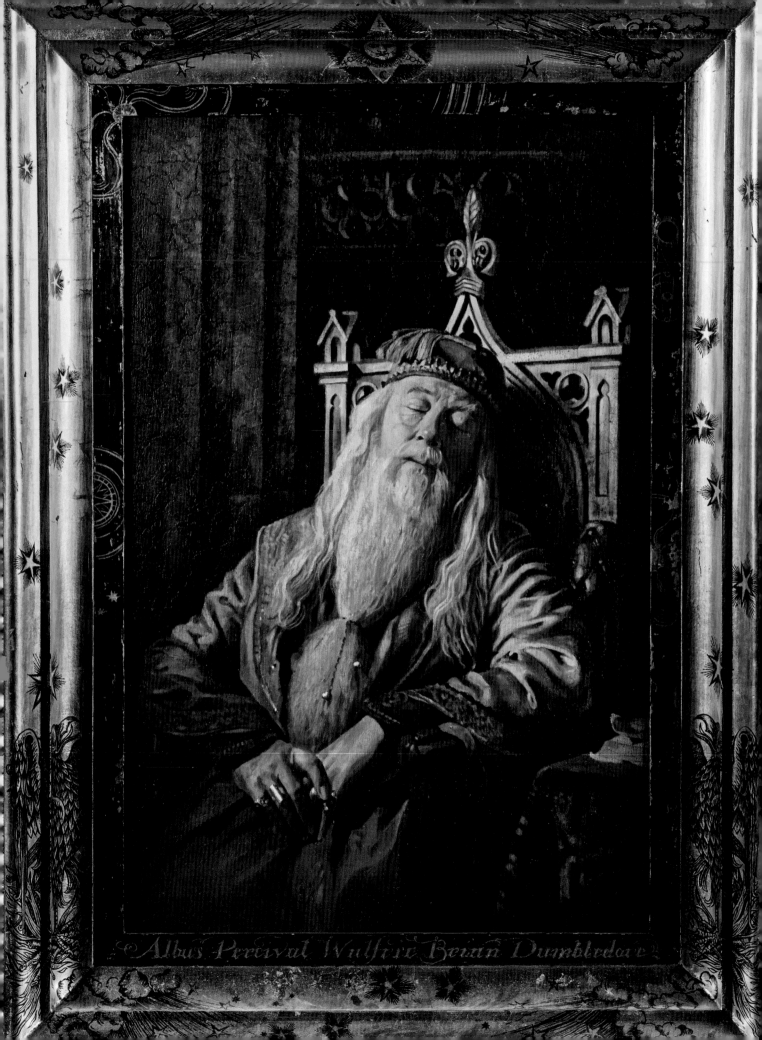

Albus Percival Wulfric Brian Dumbledore

Harry Potter™

FILM VAULT

VOLUME 11

Hogwarts Professors and Staff

By Jody Revenson

WIZARDING WORLD

INSIGHT EDITIONS

San Rafael · Los Angeles · London

INTRODUCTION

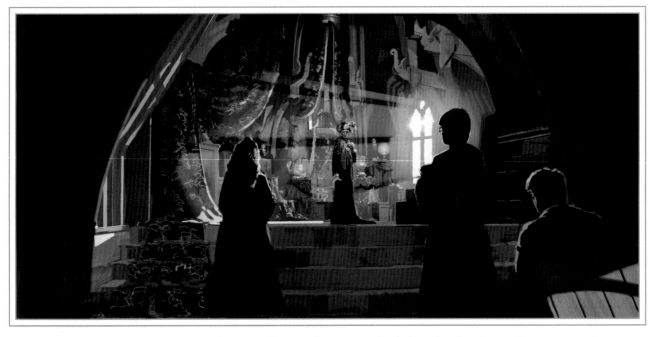

During Harry Potter's tenure at Hogwarts School of Witchcraft and Wizardry, he is taught by a variety of professors who not only educate him in the magical skills he will need to defeat the Dark Lord, Voldemort, but also impart to him their wisdom and support as Harry finds his way through his school years. Not every teacher can be considered a positive influence; in fact, some of his professors are extremely silly and others sink so low as to torment and suppress Harry and his fellow students.

Harry Potter's professors and the other Hogwarts staff members are uniquely individual in their personalities and appearance. The costume designers—Judianna Makovsky for *Harry Potter and the Sorcerer's Stone*, Lindy Hemming for *Harry Potter and the Chamber of Secrets*, and Jany Temime, who started on *Harry Potter and the Prisoner of Azkaban* and stayed for the remainder of the movies—had fun and fashionable characters to clothe, although the pressure to please the fans was always on their minds. "Trying to do the first of the series was absolutely terrifying," says Judianna Makovsky. "I really didn't want to disappoint anybody."

Creating the right costumes for the characters was essential; the fabrics and colors a character wears give audiences an important glimpse into their personality. Actors also find inspiration in their wardrobe. Before filming, each actor would meet with the costume designer to view and discuss ideas for their clothes. When actor Richard Harris visited Judianna Makovsky about costumes for Professor Albus Dumbledore for *Harry Potter and the Sorcerer's Stone*, she showed him some preliminary sketches for the headmaster. "He stared at them for a while and then said, 'Thank you. Thank you. Now I know what my character is,' and that was it. Richard Harris made it simple."

For *Harry Potter and the Chamber of Secrets*, Lindy Hemming continued with the overall look established in the first movie. "That didn't mean you had to keep them in the exact same costumes, because new scenes dictated new clothes," she explains, "but we tried not to have a jump in the look, obviously." She gives great credit to the talented craftspeople in the costume department for their skills and imagination. "They had a sensibility to make things in a straightforward way, but [they] always added little touches. They'd

PAGE 2: Portrait of Headmaster Albus Dumbledore; TOP: The crest of Hogwarts School of Witchcraft and Wizardry; ABOVE: Professor Trelawney's Divination classroom as seen in *Harry Potter and the Prisoner of Azkaban*. Art by Andrew Williamson; OPPOSITE: Potions Professor Severus Snape (Alan Rickman) sits at his office desk in *Harry Potter and the Chamber of Secrets*.

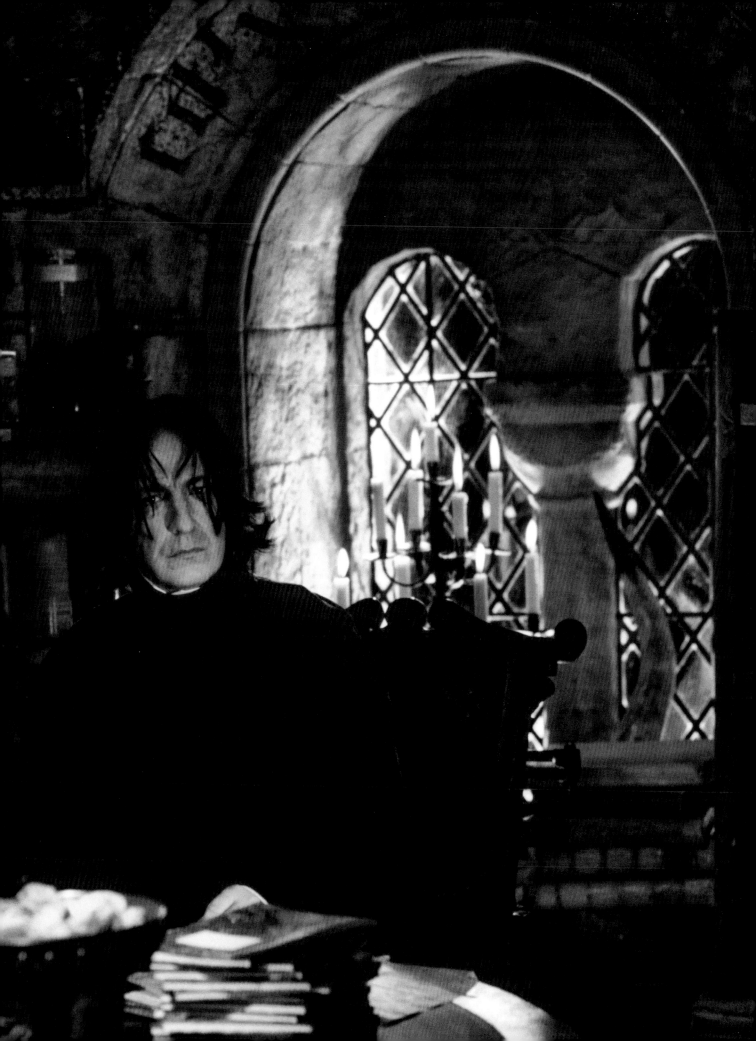

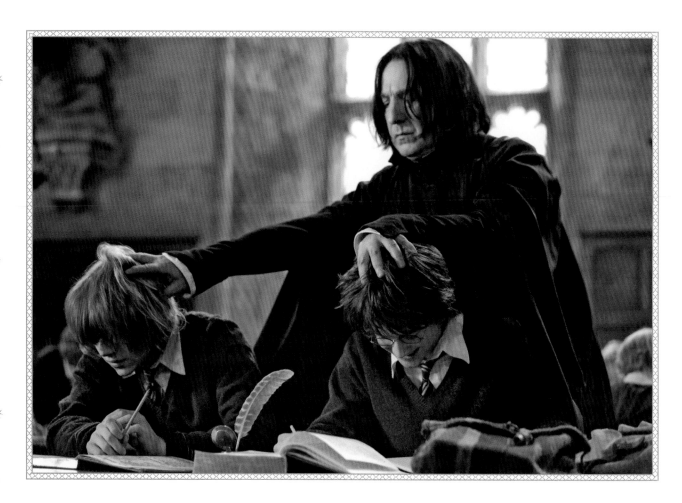

discover a marvelous button to use or suggest a strange little pocket you wouldn't have thought of that added a new dimension to the piece. These were people who loved the Harry Potter books and films so much that they wanted to give an input."

When Jany Temime joined the Harry Potter team, she "didn't realize how important [her role] was," she says. "If [I had,] I would have been completely paralyzed and incapable of doing anything!" Temime recognized that the staff and professors of Hogwarts should keep their "wizardy wear," for the most part, but she did reinterpret the look of one beloved member of the faculty. She felt that Rubeus Hagrid's wardrobe should better address his job of tending the grounds and the Dark Forest, but also reflect his new responsibility as Care of Magical Creatures professor in *Harry Potter and the Prisoner of Azkaban*, so she provided him with a pocket-filled waistcoat and thicker trousers and boots. In order to accommodate the larger versions of Robbie Coltrane's clothes needed for his double Martin Bayfield, Temime created her own prints, so they could easily be blown up to three times the original size.

The costume department worked closely with chief makeup artist Amanda Knight and chief hair stylist Eithne Fennel, who served in those roles on all eight Harry Potter films. Knight and Fennel would sit down with the costume designer several times to discuss ideas for each character's hair and look while they reviewed sketches of the outfits. They also noted that they worked with each film's director, who would want to put their

mark on the overall design as well. "We always showed them pictures of existing artists who were coming back," says Fennel, "and ask[ed] them if they were happy with that look, or did they want to change it." Sometimes, small changes were made, "but most times they were happy."

We are fortunate that the insights of all these creative women, gained by deeply educating themselves about each character, brought to life the Hogwarts professors and staff, some sporting disheveled hair or werewolf scars, others dressed in checkered tweeds, floating silks, well-worn leather, or fluffy acid pinks.

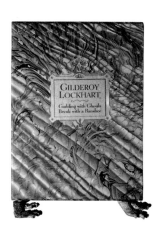
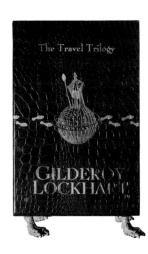

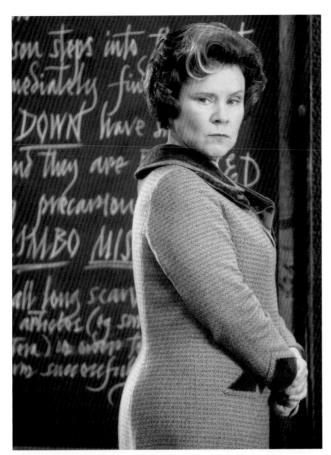

OPPOSITE TOP: Professor Snape (Alan Rickman) helps Ron Weasley (Rupert Grint) and Harry Potter (Daniel Radcliffe) with their homework assignment in *Harry Potter and the Goblet of Fire*; OPPOSITE BOTTOM: Two of Professor Gilderoy Lockhart's required textbooks; LEFT: Defense Against the Dark Arts Professor Dolores Umbridge (Imelda Staunton); BELOW: Professor Lockhart (Kenneth Branagh) begins his class year in *Harry Potter and the Chamber of Secrets*; BOTTOM: Dolores Umbridge threatens to expel Professor Sybill Trelawney (Emma Thompson), who is protected by Transfiguration Professor Minerva McGonagall (Maggie Smith) in *Harry Potter and the Order of the Phoenix*.

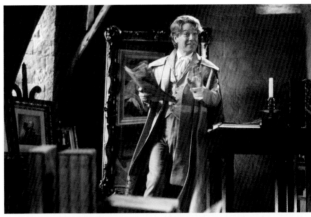

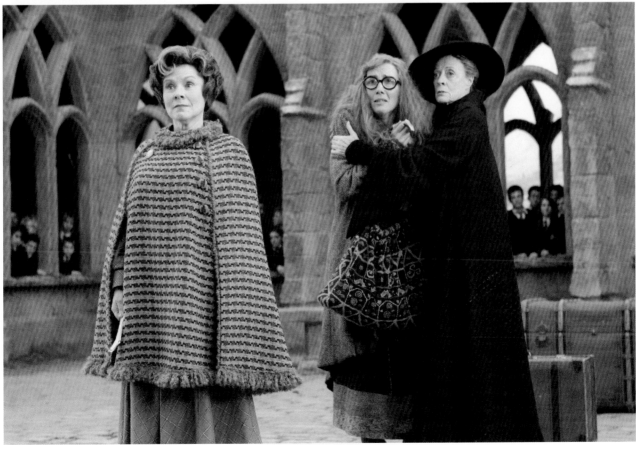

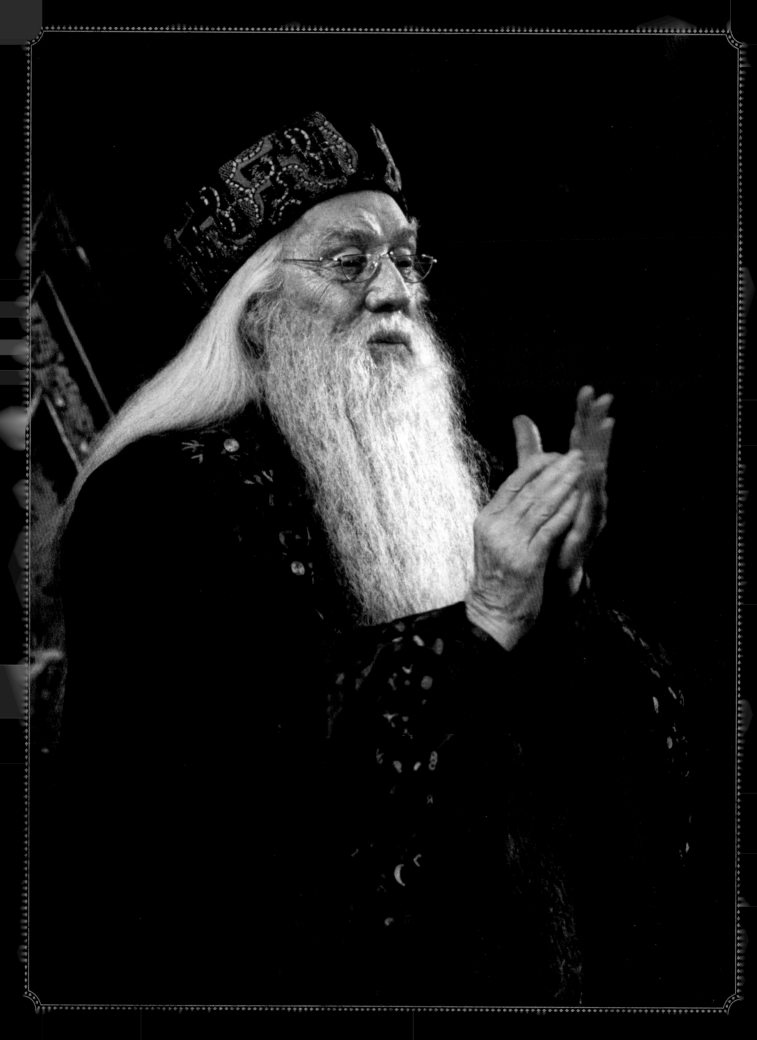

PROFESSOR DUMBLEDORE

Actor Richard Harris plays Professor Albus Percival Wulfric Brian Dumbledore, Headmaster of Hogwarts. Harris first met Daniel Radcliffe (Harry Potter), Emma Watson (Hermione Granger), and Rupert Grint (Ron Weasley) when he was asked to read a scene with them. After they finished, Rupert Grint, who had practically no acting experience, turned to Richard Harris, who had been acting for many years, and said, "Mr. Harris that was quite a good reading. I think you'll be quite good in this part!"

Author J. K. Rowling met with costume designer Judianna Makovsky and told her that Dumbledore liked clothes and had a certain amount of personal vanity. "She was insistent that he was a clotheshorse. "I think he changed clothes more than anyone else in the film." In addition to embroidery embellishments, the fabrics were silk-screened and appliqued so the material did not look "manufactured." During filming, Harris spent several hours in the makeup chair being tressed in long white hair and an equally white knee-length beard, which chief makeup artist Amanda Knight would tie up with ribbons during food breaks.

For *Harry Potter and the Chamber of Secrets,* when Harry is introduced to Fawkes in the Headmaster's office, costume designer Lindy Hemming created the robe Dumbledore wears using antique pieces of fabric and cutouts from an old tapestry. Dumbledore also required a costume for scenes that take place fifty years earlier. Michael O'Connor, associate costume designer, felt that Dumbledore's wardrobe needed only to be simpler. "We kept the same colors and textures, just not as elaborate as they are when he's the Headmaster of Hogwarts. So we kept the wardrobe in purples and rich browns and golds, and

FIRST APPEARANCE:
Harry Potter and the Sorcerer's Stone

ADDITIONAL APPEARANCES:
Harry Potter and the Chamber of Secrets
Harry Potter and the Prisoner of Azkaban
Harry Potter and the Goblet of Fire
Harry Potter and the Order of the Phoenix
Harry Potter and the Half-Blood Prince
Harry Potter and the Deathly Hallows – Part 1
Harry Potter and the Deathly Hallows – Part 2

HOUSE:
Gryffindor

OCCUPATION:
Hogwarts Headmaster

MEMBER OF:
Order of the Phoenix

PATRONUS:
Phoenix

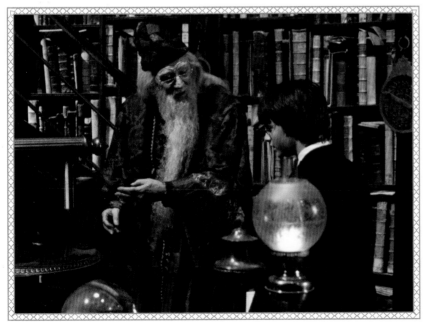

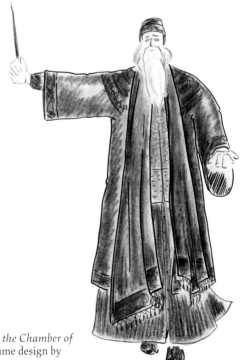

OPPOSITE: Dumbledore wears the robe that included old tapestry pieces in *Harry Potter and the Chamber of Secrets;* ABOVE: With Harry in the Headmaster's office in *Chamber of Secrets;* RIGHT: Costume design by Judianna Makovsky for one of Dumbledore's robes, sketch by Laurent Guinci.

made the silhouette slightly smaller and less exaggerated." Sadly, after the second film was completed, actor Richard Harris passed away.

Actor Michael Gambon would now take on the role of Dumbledore. So Jany Temime combined the original concept that the Headmaster loved dressing up with the personality of the new actor portraying him. "I felt Dumbledore was somebody who was always moving, somebody who was very spirited and very sure of himself." *Harry Potter and the Prisoner of Azkaban* director Alfonso Cuarón agreed, and gave her his own thoughts. "His description was 'old hippie,' but still very chic and with a lot of class. He said that Dumbledore was the sort of man who, when he sat down, everything would fall into place naturally." Temime dressed the Headmaster in layers of tie-dyed silks that moved with him, and changed out high, pointed wizard hats for a style that resembles Victorian "Oriental" tasseled smoking caps. He was additionally adorned with Celtic-design rings, and often tied his beard with a thin chain. Temime was also charged with dressing a much younger Dumbledore when he visits the orphan Tom Riddle in *Harry Potter and the Half-Blood Prince*, and it's clear that he enjoyed wearing the flamboyant clothes of that time.

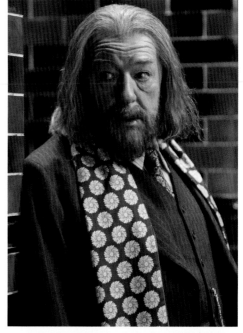

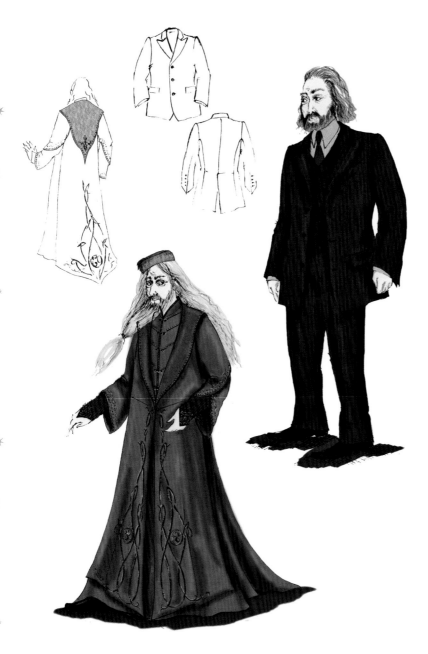

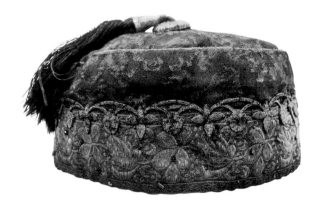

> *"As long as Dumbledore's around, Harry, you're safe.*
> *As long as Dumbledore's around, you can't be touched."*

Hermione Granger, *Harry Potter and the Sorcerer's Stone*

Gambon was often asked what it was like to take over the role of Dumbledore from Richard Harris, and he would explain that he likened it to playing a Shakespearean role such as King Lear. "So many actors have played Lear," he says, "and none of us worry about what the previous actor has done; you just take the part and make it your own." Gambon did subtly give tribute to Harris in his characterization. "I am originally Irish, and on my first day of shooting, the Irish accent just came out," says Gambon. "Alfonso liked it, so I kept it. I think of it as my homage to Richard."

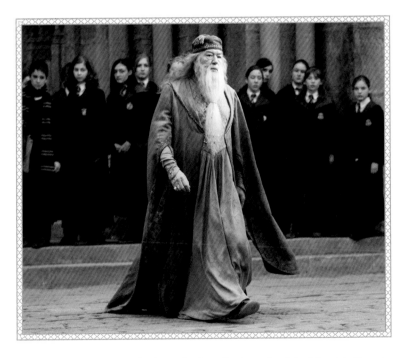

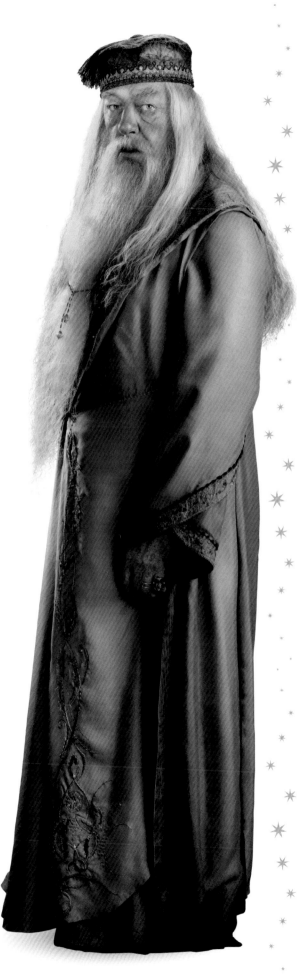

OPPOSITE BOTTOM LEFT: Robe design by Jany Temime, sketch by Mauricio Carneiro for *Harry Potter and the Half-Blood Prince*; OPPOSITE CENTER LEFT AND TOP RIGHT: Wardrobe for a flashback in *Half-Blood Prince* epitomized the style of the times. Suit design by Jany Temime, sketch by Mauricio Carneiro; OPPOSITE CENTER AND BOTTOM RIGHT: Close-ups of embroidery details on one of the robes; TOP: An Oriental-style cap; ABOVE: As Dumbledore's power was tested, his wardrobe became more gray; RIGHT: A costume reference photo for *Half-Blood Prince*.

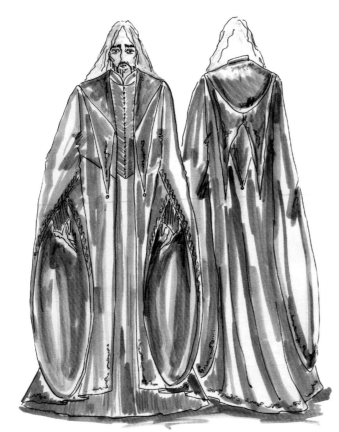

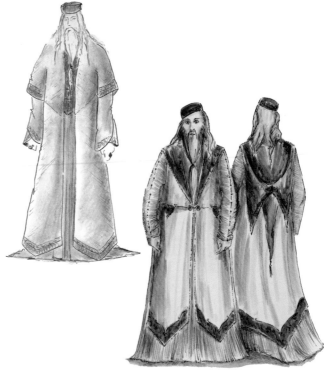

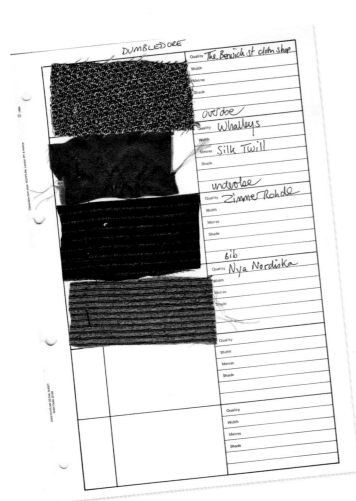

DUMBLEDORE

	Quality The Berwick st cloth shop
	Width
	Metres
	Shade
	overdse
	Quality Whaleys
	Width Silk Twill
	Metres
	Shade
	underdse
	Quality Zimmer Rohde
	Width
	Metres
	Shade
	bib
	Quality Nya Nordiska
	Width
	Metres
	Shade
	Quality
	Width
	Metres
	Shade
	Quality
	Width
	Metres
	Shade

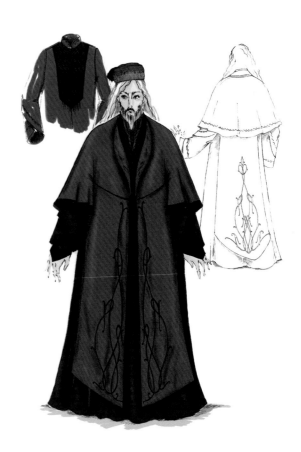

DUMBLEDORE'S WAND

When they first fashioned Headmaster Albus Dumbledore's wand, the designers had no idea how important that wand would be to the story. The Elder Wand is made from a piece of English oak, with a bone inlay at the handle decorated with runes. "It's very thin as a wand," says Pierre Bohanna, "but it has these outcrops of nodules every few inches, so it's very recognizable, even from a distance." Bohanna was grateful the wand's design was so distinctive. "Obviously, it's the biggest gun on the set, so to speak. As far as wands are concerned, it's the wand to beat all others."

OPPOSITE PAGE: A collection of robes designed by Jany Temime for *Harry Potter and the Goblet of Fire,* sketches by Mauricio Carneiro (top left and right); for *Harry Potter and the Prisoner of Azkaban,* sketch by Laurent Guinci (top center); and for *Harry Potter and the Order of the Phoenix,* sketch by Mauricio Carneiro (right); OPPOSITE LEFT: Swatches of fabric on a chart used for the costumes designed for *Order of the Phoenix;* THIS PAGE: Daniel Radcliffe and Michael Gambon filming on the Cave set in *Harry Potter and the Half-Blood Prince* (top); Dumbledore in Budleigh Babberton in *Half-Blood Prince* (left).

RUBEUS HAGRID

"Hagrid is a larger-than-life character," says producer David Heyman, "and we wanted somebody who we knew could be tough and dangerous but at the same time warm, vulnerable, and very funny. And Robbie Coltrane is all those things."

"Children like Hagrid because he's big and strong and kind and that's what children want," says Robbie Coltrane. "They want somebody who could protect them and somebody who's nice to them—and a lot of children don't have a person like that in their lives, which is very sad."

Once Hagrid was cast, the production team needed to make decisions about how the half-giant would interact with the considerably smaller ensemble. In movies with similar considerations, the characters are placed in digitally, which ultimately complicates filming and visual effects. Creature effects designer Nick Dudman suggested that for the long shots a large double for Hagrid could be used. Concern for finding someone who could fulfill the gigantic proportion required was voiced, but Dudman was nonplussed. "We thought that if we used the tallest person we could find, and then scaled him up via a suit as big as we could go, we could get to a height of about seven foot seven." Martin Bayfield, a six foot ten ex-England rugby player, was hired. "We life-cast both of them," says Dudman, "and then basically constructed a Robbie suit with a static head that Martin would wear." The studio—along with Dudman—wasn't completely convinced that it would work until a test that the crew put together for director Chris Columbus and producer David Heyman. Coltrane was filmed in costume and then Bayfield emerged from behind a door, mimicking Coltrane's walk and even imitating lines from a bank commercial Coltrane had recently filmed. Columbus and Heyman—and especially Dudman—were completely enthralled and satisfied with the results. Bayfield did have the opportunity to play Hagrid without the animatronic head, portraying him as a student in *Harry Potter and the Chamber of Secrets.*

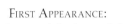

FIRST APPEARANCE:
Harry Potter and the Sorcerer's Stone

ADDITIONAL APPEARANCES:
Harry Potter and the Chamber of Secrets
Harry Potter and the Prisoner of Azkaban
Harry Potter and the Goblet of Fire
Harry Potter and the Order of the Phoenix
Harry Potter and the Half-Blood Prince
Harry Potter and the Deathly Hallows – Part 1
Harry Potter and the Deathly Hallows – Part 2

HOUSE:
Gryffindor

OCCUPATION:
Keeper of Keys and Grounds of Hogwarts,
Care of Magical Creatures professor
(from third year)

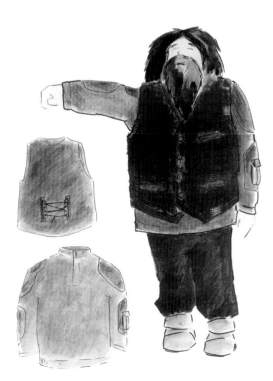

LEFT: Hagrid wears heat-protective gloves in *Sorcerer's Stone;* RIGHT: Jany Temime added more functionality to Hagrid's clothes starting with *Harry Potter and the Prisoner of Azkaban,* costume sketch by Laurent Guinci; OPPOSITE: Robbie Coltrane in a publicity photo for *Harry Potter and the Sorcerer's Stone.*

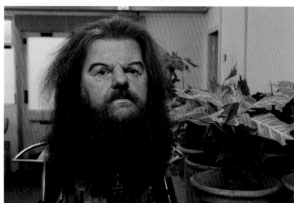

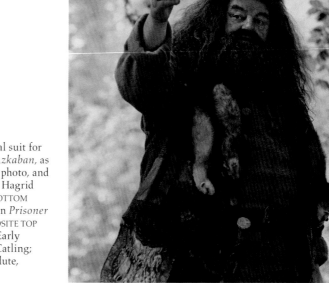

TOP LEFT TO RIGHT: Jany Temime designed a furry formal suit for Hagrid, first worn in *Harry Potter and the Prisoner of Azkaban*, as seen in a sketch by Laurent Guinci, a costume reference photo, and a close-up detail; CENTER RGHT: An animatronic head for Hagrid sits next to some Mandrake pots in the creature shop; BOTTOM RIGHT: As the new Care of Magical Creatures professor in *Prisoner of Azkaban*, Hagrid needed a more utilitarian coat; OPPOSITE TOP RIGHT: Hagrid's moleskin coat; OPPOSITE BOTTOM RIGHT: Early concept art of Hagrid with his umbrella wand, by Paul Catling; OPPOSITE LEFT: Visual development sketches of Hagrid's flute, played in *Harry Potter and the Sorcerer's Stone*.

> *"There's no Hogwarts without you, Hagrid."*
>
> Harry Potter, *Harry Potter and the Chamber of Secrets*

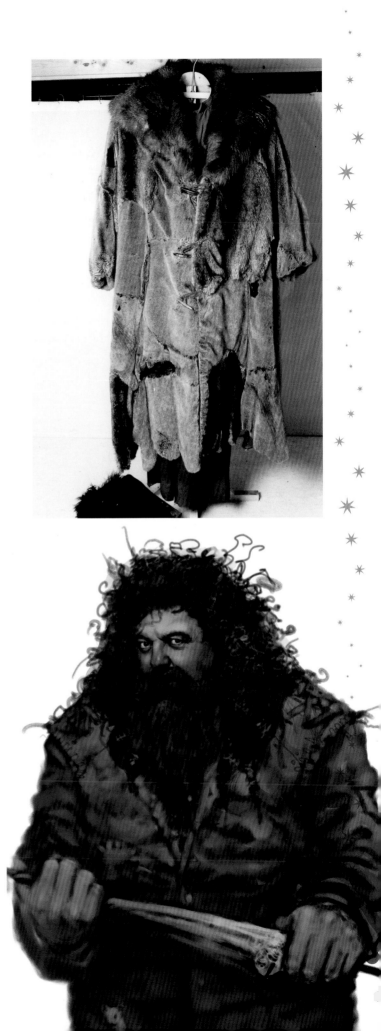

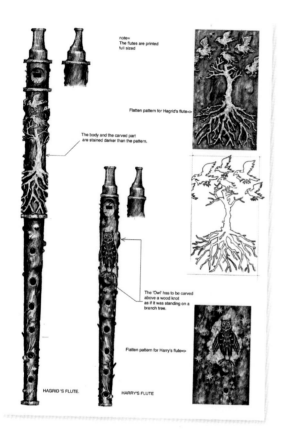

note=
The flutes are printed
full sized

Flatten pattern for Hagrid's flute=>

The body and the carved part
are stained darker than the pattern.

The 'Owl' has to be carved
above a wood knot
as if it was standing on a
branch tree.

Flatten pattern for Harry's flute=>

HAGRID'S FLUTE. HARRY'S FLUTE

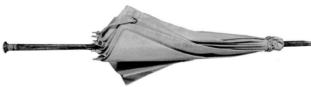

HAGRID'S WAND

The pieces of Rubeus Hagrid's wand are hidden in a pink umbrella, seen when he uses it to conjure a fire in *Harry Potter and the Sorcerer's Stone*. Just as his costumes needed to be created in two different sizes, a London umbrella maker did the same for Hagrid's umbrella/wand. Because Hagrid is not actually allowed to use his wand, we do not see him raise it in memorial to Dumbledore in *Harry Potter and the Half-Blood Prince*.

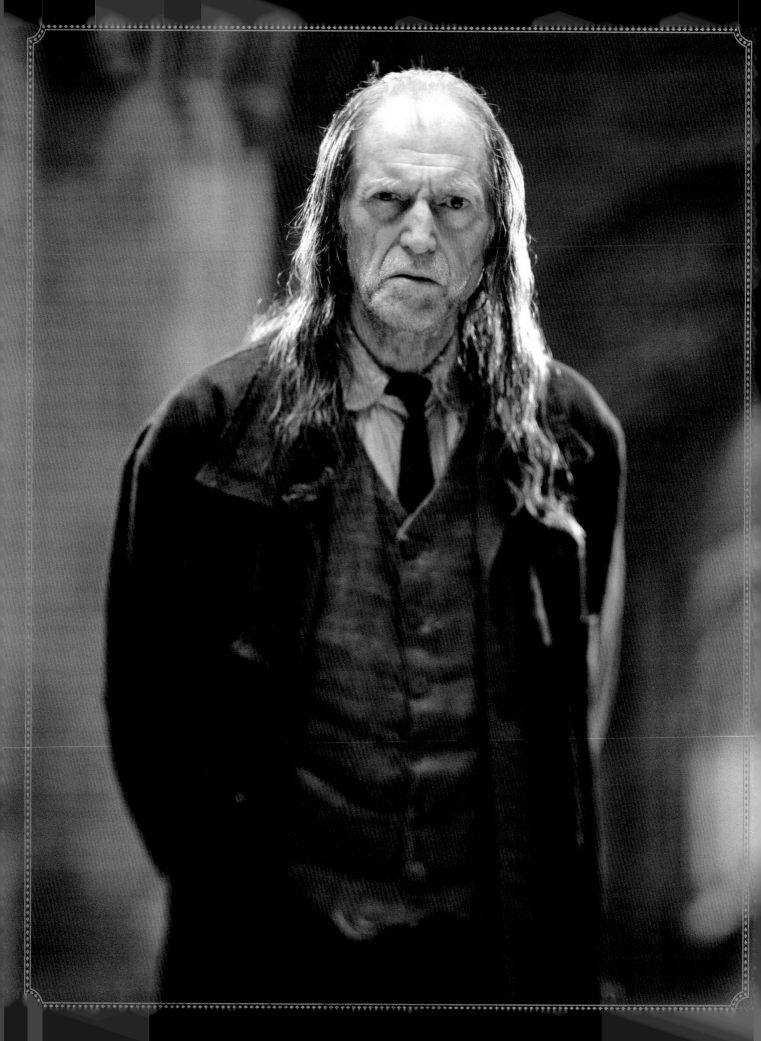

ARGUS FILCH

After they had read the first few Harry Potter novels, actor David Bradley asked his children which part they thought he should play in the films if he could. "They said I was a natural for Filch," he recalls with a smile, "and I thought, is that how my kids see me? This horrible, greasy, odious, vicious man? Isn't that nice." To their delight, Bradley was asked to audition for the role, and "they were on the ceiling when my agent called and said I was cast."

Before filming started, Bradley had meetings with the costume and makeup departments, who dressed him, he describes, as "a cross between a medieval pickpocket and someone from the Wild West. There was quite a bit of greasy leather and odd bits of fake animals skin in that saggy overcoat." Filch's look is completed with straggly hair extensions, stubble, and a set of repulsive false teeth. Jany Temime adjusted Filch's costume slightly, decreasing the oily, ragged look of his vests and tailcoats, and incorporating more of a caretaker's uniform with a color palette that stayed mostly in the brown and gray range. As the films progressed, Filch continued to clean up, even wearing a proper black formal suit at the Yule Ball in *Harry Potter and the Goblet of Fire*, and long quilted armor-like padding in *Harry Potter and the Deathly Hallows – Part 2* during battle scenes.

Over the course of the films, Bradley found it easy to become one with his character. "Once I get into those big, dirty boots and old overcoat, and slide on the teeth, I slip into him and have great fun. I'm not saying I *like* him. I like him as a character but I wouldn't go out for a coffee with him."

FIRST APPEARANCE:
Harry Potter and the Sorcerer's Stone

ADDITIONAL APPEARANCES:
Harry Potter and the Chamber of Secrets
Harry Potter and the Prisoner of Azkaban
Harry Potter and the Goblet of Fire
Harry Potter and the Order of the Phoenix
Harry Potter and the Half-Blood Prince
Harry Potter and the Deathly Hallows – Part 2

OCCUPATION:
Caretaker of Hogwarts

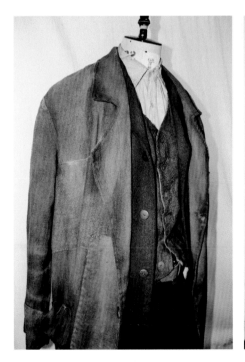

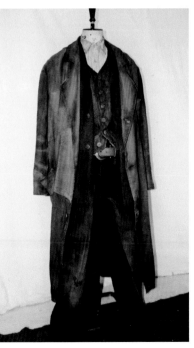

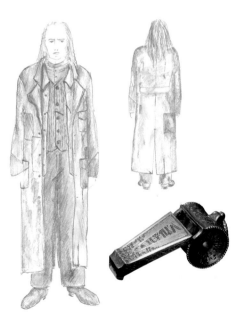

OPPOSITE: A publicity photo for *Harry Potter and the Goblet of Fire* displays Filch's formal suit; ABOVE LEFT AND RIGHT: The costume breakdown work is evident in this suit ensemble for *Harry Potter and the Prisoner of Azkaban*; CENTER RIGHT: Sketches by Laurent Guinci of Filch's wardrobe designed by Jany Temime for *Harry Potter and the Deathly Hallows – Part 2*; RIGHT: A rune-inscribed whistle from *Harry Potter and the Order of the Phoenix*.

"A pity they let the old punishments die."

Argus Filch, *Harry Potter and the Sorcerer's Stone*

MADAM POMFREY

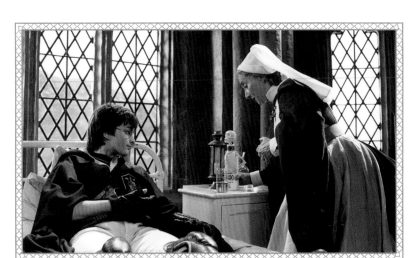

FIRST APPEARANCE:
Harry Potter and the Chamber of Secrets

ADDITIONAL APPEARANCES:
Harry Potter and the Half-Blood Prince
Harry Potter and the Deathly Hallows – Part 2

OCCUPATION:
Hospital Matron

Madam Poppy Pomfrey, first seen in *Harry Potter and the Chamber of Secrets*, is a character that actress Gemma Jones finds "clearly identifiable. I've got lots of fun fan mail from young people who obviously recognize the character that they've read in the books." It's not surprising that an educational institution such as Hogwarts should have its own version of the "school nurse," in this case a matron, and costumer Judianna Makovsky ensured that Madam Pomfrey had her own distinguishable robes. Keeping to the overall choice of a Dickensian-era familiarity for the wizarding wardrobes, Pomfrey wears a uniform that resembles those of the women educated at the Nightingale Training School, established in England in the 1860s. The high, starched collar, peaked hat, and long dress/apron combination was believed to be the most protective outfit to wear against disease. Madam Pomfrey's costume includes the nurse's standard equipment of a timepiece, and she wears a pin in the shape of an hourglass.

Madam Pomfrey's uniform was revised for *Harry Potter and the Half-Blood Prince*. Jany Temime kept Pomfrey in a similar color scheme—the white and red originated by the American Red Cross brought over the Atlantic by World War I nurses—but gave the outfit more wizardy points. The sleeves are puffed up and the collar comes down in sharp-ending triangles. Temime also provided her with a red-colored cape/cloak combo for outdoor scenes.

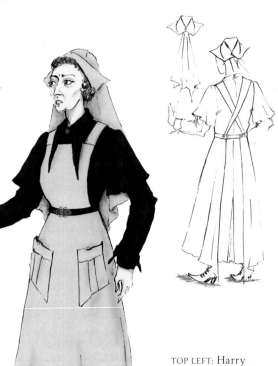

POMFREY'S WAND

Madam Pomfrey's baton-style wand is hewed from a dark wood, with a knob shape at the handle. Actress Gemma Jones (Pomfrey) enjoyed her fight scenes for *Harry Potter and the Deathly Hallows – Part 2*. "When filming, it's a bit tame, though the stunt people are flinging themselves onto the ground or hurling themselves in the air," she says. "But when everything's put on, in special effects, with sparks and flashes coming out of our wands, you realize how powerful you are!"

TOP LEFT: Harry Potter is attended by the hospital matron in *Harry Potter and the Chamber of Secrets*; ABOVE AND OPPOSITE: Pomfrey's outfit was redesigned by Jany Temime as seen in sketches by Mauricio Carneiro and in a scene from *Harry Potter and the Deathly Hallows – Part 2*.

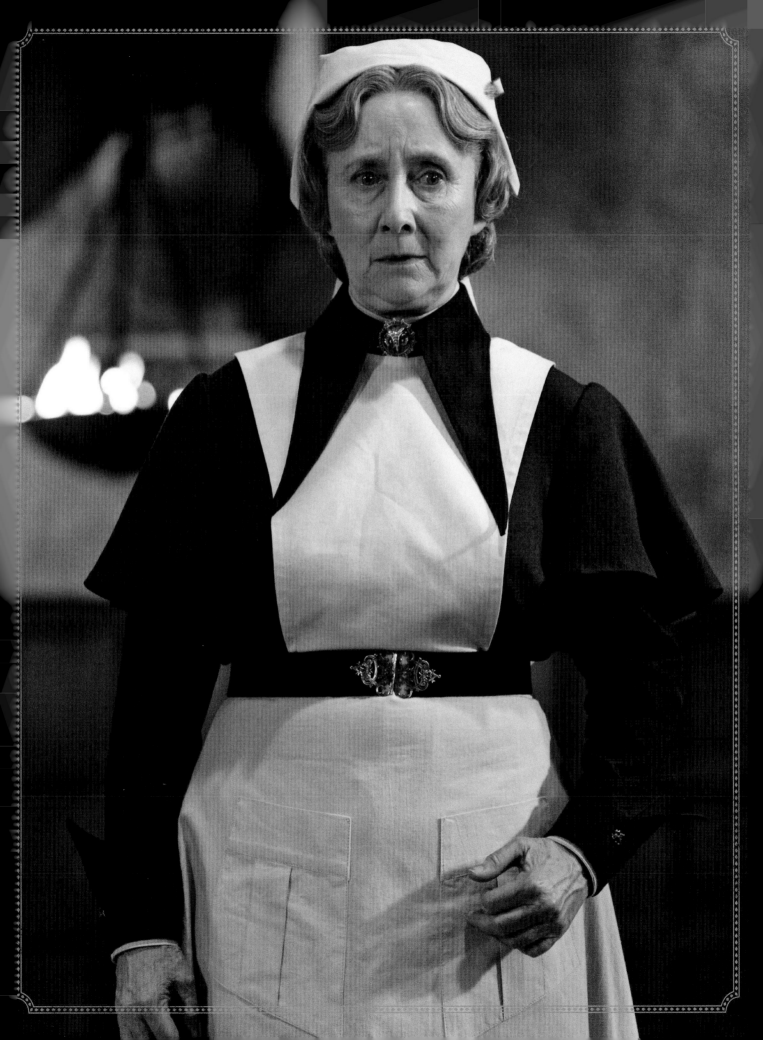

MADAM HOOCH

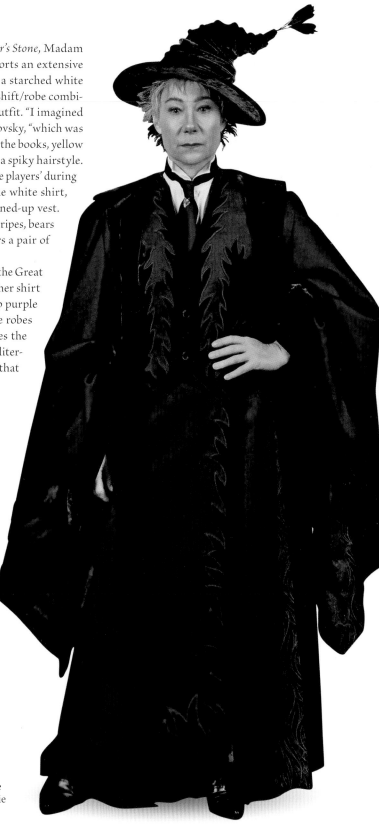

Although she appears in only *Harry Potter and the Sorcerer's Stone*, Madam Rolanda Hooch, played by actress Zöe Wanamaker, sports an extensive wardrobe. As flying instructor for the students, Hooch wears a starched white shirt and a tie bearing the Hogwarts crest under a heavy wool shift/robe combination. Thick leather gloves and a brass whistle complete the outfit. "I imagined Madam Hooch as sort of a gym instructor," says Judianna Makovsky, "which was confirmed by Jo [Rowling] in our conversations." As depicted in the books, yellow hawk-like eyes were added via contact lenses to the actress, and a spiky hairstyle.

Madam Hooch wears a robe, pants, and guards similar to the players' during the Quidditch game, as she flies alongside them as referee. The white shirt, tie, and whistle are still present, this time under a sharp buttoned-up vest. Her split-tail black robe, lined in white and decorated in white stripes, bears the Hogwarts crest and has tied-back sleeves. Hooch also wears a pair of yellow-tinted goggles.

But her flashiest incarnation is seen at the teachers' table in the Great Hall, as she's attired in a showy set of purple robes. This time, her shirt collar points are tipped up, her tie is silk, and her robe has deep purple velvet accents. The vest and sleeves of her dress suit under the robes are bordered in a pattern that mimics licks of flames and gives the illusion of motion even when she's standing still. To top it off—literally—Hooch's pleated hat ends in a purple and white flourish that clearly resembles the brush end of a broomstick.

ABOVE: The flight instructor teaches the first years in her training robes in *Harry Potter and the Sorcerer's Stone;* RIGHT: Zöe Wanamaker poses in flame-decorated robes for a publicity photo; OPPOSITE TOP AND LEFT: Hooch's referee robes in costume reference shots and worn in a Quidditch game; OPPOSITE INSET: Close-up of tie with Hogwarts crest.

APPEARANCE:
Harry Potter and the Sorcerer's Stone

OCCUPATION:
Flying instructor,
Quidditch referee

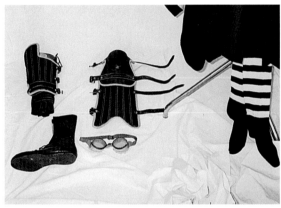

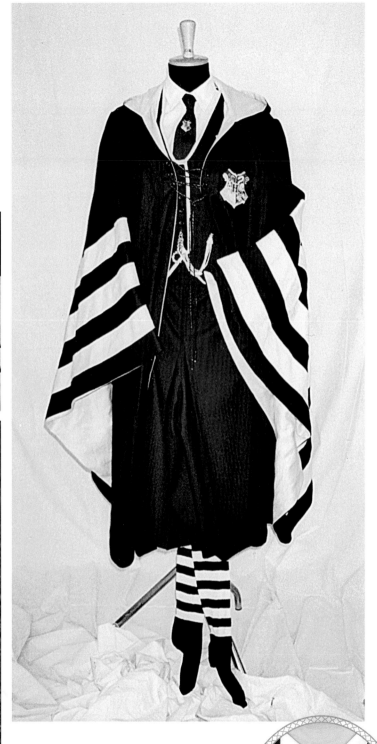

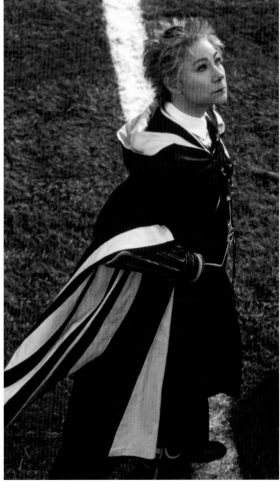

"Welcome to your first flying lesson. Well? What are you waiting for?"

Madam Hooch, *Harry Potter and the Sorcerer's Stone*

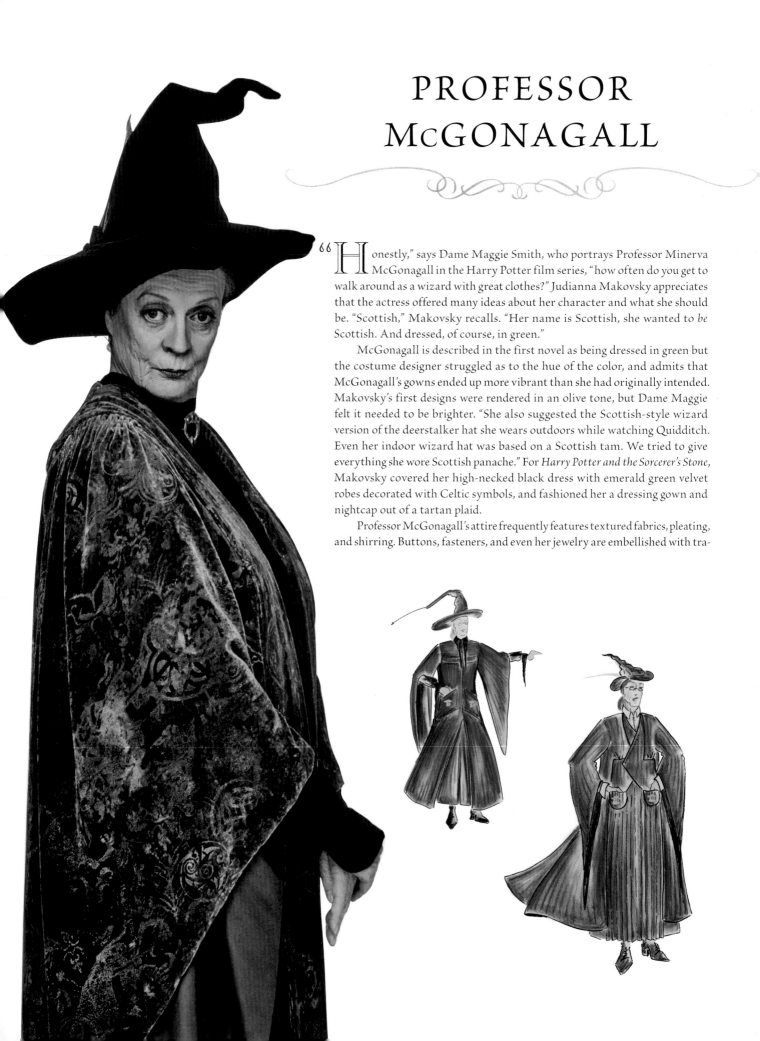

PROFESSOR McGONAGALL

"Honestly," says Dame Maggie Smith, who portrays Professor Minerva McGonagall in the Harry Potter film series, "how often do you get to walk around as a wizard with great clothes?" Judianna Makovsky appreciates that the actress offered many ideas about her character and what she should be. "Scottish," Makovsky recalls. "Her name is Scottish, she wanted to *be* Scottish. And dressed, of course, in green."

McGonagall is described in the first novel as being dressed in green but the costume designer struggled as to the hue of the color, and admits that McGonagall's gowns ended up more vibrant than she had originally intended. Makovsky's first designs were rendered in an olive tone, but Dame Maggie felt it needed to be brighter. "She also suggested the Scottish-style wizard version of the deerstalker hat she wears outdoors while watching Quidditch. Even her indoor wizard hat was based on a Scottish tam. We tried to give everything she wore Scottish panache." For *Harry Potter and the Sorcerer's Stone,* Makovsky covered her high-necked black dress with emerald green velvet robes decorated with Celtic symbols, and fashioned her a dressing gown and nightcap out of a tartan plaid.

Professor McGonagall's attire frequently features textured fabrics, pleating, and shirring. Buttons, fasteners, and even her jewelry are embellished with tra-

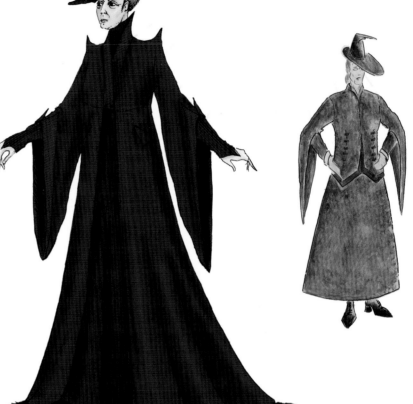

"Why is it, when something happens, it is always you three?"

Professor McGonagall, *Harry Potter and the Half-Blood Prince*

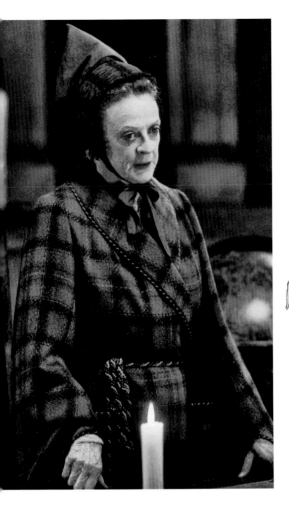

ditional Celtic imagery. Jany Temime tailored several McGonagall's robes with sleeves that were form-fitting to her elbows, then hung down in long points, pleased that the actress "really uses what I give her. She uses the gown, she uses the sleeves. She gives them a nice theatricality." Temime changed the color to a darker, more burnished green, and incorporated what she refers to as "wizardy" elements, adding high points to the shoulders of McGonagall's robes and collars.

OPPOSITE RIGHT: Preliminary costume designs by Judianna Makovsky, sketched by Laurent Guinci for *Harry Potter and the Sorcerer's Stone*; OPPOSITE FAR LEFT: Dame Maggie strikes a professorial pose in a publicity photo for *Sorcerer's Stone*; TOP LEFT: Even McGonagall's bathrobe and sleeping cap, seen in *Sorcerer's Stone*, were infused with Scottish style; TOP CENTER: A darker, pointier silhouette was evident in Jany Temime's costume design for *Harry Potter and the Half-Blood Prince*, sketch by Mauricio Carneiro; TOP RIGHT: Judianna Makovsky suggests a different color palette in an early costume sketch by Laurent Guinci; ABOVE: Close-up of the Transfiguration professor's boots.

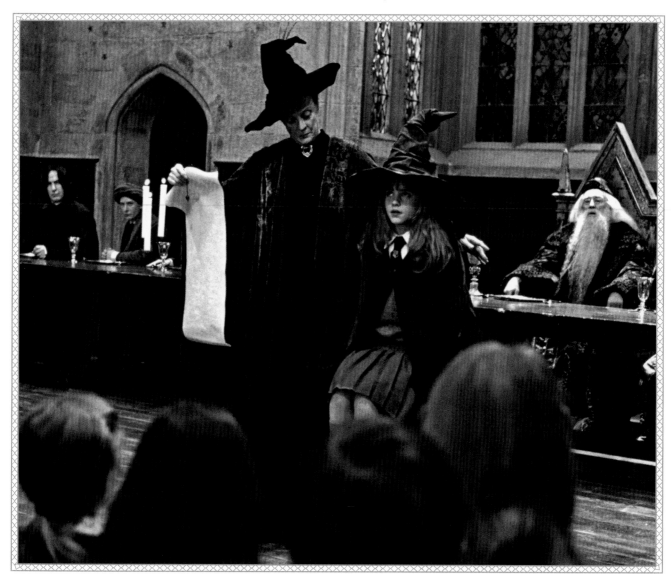

MᴄGONAGALL'S WAND

Prop modeler Pierre Bohanna describes the design of Minerva McGonagall's wand as "no-nonsense." The sleek black-tipped wand is topped by a carving that seemingly resembles the turned leg on a piece of Victorian furniture, and is finished with a small amber stone at the end of the handle. Maggie Smith thought that her wand battle with Alan Rickman (Severus Snape) in *Harry Potter and the Deathly Hallows – Part 2* would be more physical, and practiced her wand moves as if she was wielding a foil, but realized, "Of course, wands work in a magical way. It can be a long distance from each other when you have a wand."

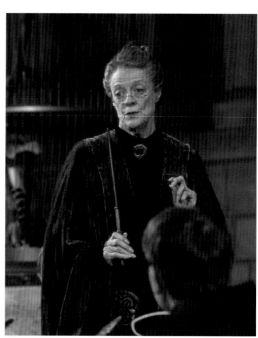

ABOVE: Professor McGonagall places the Sorting Hat on Hermione Granger's head in *Harry Potter and the Sorcerer's Stone*; RIGHT: Jewelry with Celtic designs often enhanced McGonagall's neckline, as seen in *Harry Potter and the Chamber of Secrets*.

The Sorting Hat

Professor McGonagall manages the Sorting Ceremony at Hogwarts when Harry Potter is sorted into Gryffindor in *Harry Potter and the Sorcerer's Stone*. During the Sorting Ceremony, the Sorting Hat is placed upon the head of each first-year student, and then it sorts the student into one of four houses. Though neither human nor creature, the hat exhibits its own distinctive and imposing character.

The filmmaker's first attempt at bringing the Sorting Hat to cinematic life, in *Harry Potter and the Sorcerer's Stone*, was as a puppet. But as Judianna Makovsky explains, "It didn't look like a hat. It looked like a puppet." Director Chris Columbus asked Makovsky to fabricate a Hat, to which Makovsky responded, "Well, I can make a hat, but I can't make it talk." When the hat was brought to the set, it pleased the filmmakers but confused second unit director Robert Legato, who asked how it would talk. "And Chris looked at him and said, 'Well, she made the hat, you make it talk.'" The Sorting Hat was voiced by actor Leslie Phillips, whose distinctive sound benefited from elocution lessons as a child in order to lose his original Cockney accent.

The hat Makovsky constructed wasn't actually used for the Sorting Ceremony. Instead, an apparatus that works in a way similar to motion capture technology was placed on the actors' heads, and the talking hat was animated digitally. But the Sorting Hat was realized in full, out of suede and lined with horsehair canvas, for its place in Dumbledore's office in *Harry Potter and the Chamber of Secrets* and for the final battle of Hogwarts in *Harry Potter and the Deathly Hallows – Part 2*.

Over the course of the films, seven hats were created. Costume fabricator Steve Kill soaked the material in hot water for ten minutes to soften it, then "[squashed] it down into itself." This was left overnight above a heating unit, and the next day the hat was rigged with wire inside to keep its form. Each hat was then dyed, "broken down" to give it age, and printed lightly with Celtic symbols. As Kill admits, the wrinkles are different on each hat, but "of course, you never see them next to each other."

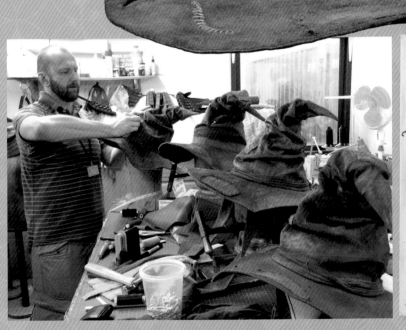

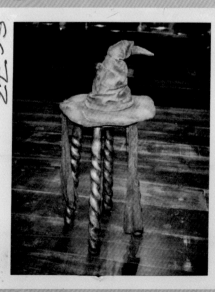

TOP: The Sorting Hat; ABOVE LEFT: Costume fabricator Steve Kill works on one of several iterations of the Sorting Hat; ABOVE RIGHT: Continuity shot on the Great Hall set, *Harry Potter and the Sorcerer's Stone*.

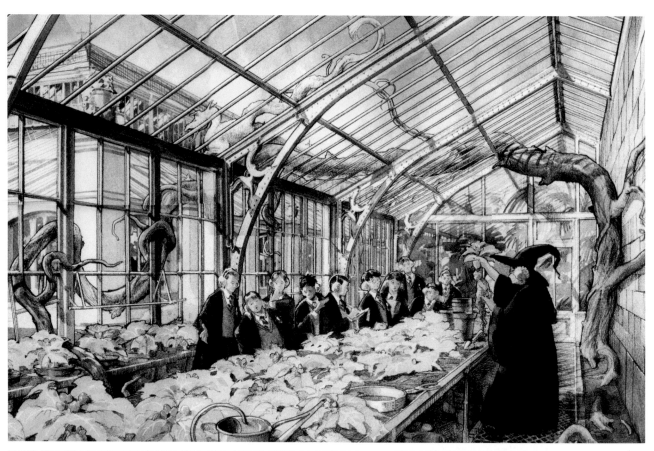

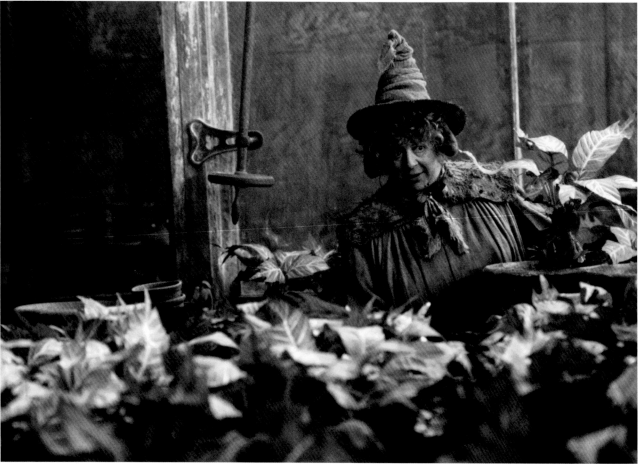

PROFESSOR SPROUT

⁶⁶ I remember going up for the interview for Professor Sprout," says actress Miriam
Margoyles, "and being absolutely over the moon that I'd gotten the job."

Herbology Professor Pomona Sprout's wardrobe for *Harry Potter and the Chamber of Secrets* is as organic as her subject matter. Dressed in a palette of earth tones, leafy shapes are used as accents on her robes: Greenery seems to grow from her cuffs and capelike collar. The witch's hat she wears in the greenhouse is constructed in a burlap-style material, and "sprouts" leaves from the tip. As she works with plants such as Mandrakes and Venomous Tentacula leaves, she wears a pair of thick, beat-up gloves, bolstered with twine, and, of course, sports a large pair of ear muffs. Sprout's outfit appeared more utilitarian in *Harry Potter and the Deathly Hallows – Part 2*. She wears a pair of thick blue overalls and a checkered shirt beneath her robe, which resembles a late eighteenth-century smock coat. Smock coats, featuring the characteristic pleats called "tubes," were used primarily by agricultural workers, as they provided both warmth and elasticity.

FIRST APPEARANCE:
Harry Potter and the Chamber of Secrets

ADDITIONAL APPEARANCE:
Harry Potter and the Deathly Hallows – Part 2

HOUSE:
Hufflepuff

OCCUPATION:
Herbology professor,
Head of Hufflepuff House

SPROUT'S WAND

The rough surface of Pomona Sprout's wand resembles the grainy, diveted wood of a tree branch. The prop modelers looked extensively for interestingly shaped or textured pieces of wood, whether precious hardwoods or not, and tried to fashion the wand to the wizard.

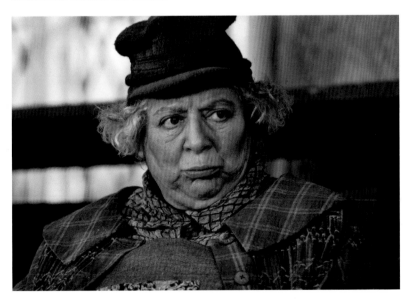

OPPOSITE TOP: Concept art by Andrew Williamson of the Herbology greenhouse in *Harry Potter and the Chamber of Secrets;* OPPOSITE BOTTOM: The organically dressed Professor Sprout among the Mandrakes in *Chamber of Secrets;* RIGHT: Costume sketch by Mauricio Carneiro of Jany Termime's new design for Sprout's robe; ABOVE: The professor had a more manufactured look in *Harry Potter and the Deathly Hallows – Part 2.*

PROFESSOR FLITWICK

I n *Harry Potter and the Sorcerer's Stone* and *Harry Potter and the Chamber of Secrets*, Warwick Davis portrays Charms Professor Filius Flitwick as wizened, silver-bearded, bald, and academically gowned. The next time Davis portrays Flitwick on-screen, in *Harry Potter and the Prisoner of Azkaban*, the teacher is a mustachioed, black-haired younger man attired in a tailed tuxedo. "The change between *Chamber of Secrets* and *Prisoner of Azkaban* is the question I get asked the most by fans," Davis says. It came about when his character simply didn't make it into the script for *Prisoner of Azkaban*. Producer David Heyman called the actor to apologize and then asked if he was interested in playing another role—that of the Frog Choir conductor. Davis, director Alfonso Cuarón, and special creature effects designer Nick Dudman devised the formal, operatically themed look, and when Davis returned to play Flitwick in *Harry Potter and the Goblet of Fire*, director Mike Newell liked it and wanted to keep it. So in addition to teaching Charms, Flitwick became what Davis calls the "professor of magical music."

The original Flitwick makeup took four hours to apply; the new version took only two and a half. "And I think a lot of people on the set don't know what I really look like," Davis says with a laugh, "because I arrive a few hours before everyone else and go home later, after the makeup's removed." The younger Flitwick's makeup consists of a prosthetic forehead that wraps around to the back under a hairpiece. Davis also wears fake ears, a fake nose, and false teeth. "I love the teeth, and want my own set so I can do toothpaste commercials," he teases.

The younger, fitter look inspired Davis to suggest a bit of business for *Goblet of Fire*. "At the end of the Yule Ball, my character introduces a rock band. So, stupidly, on a Friday evening, I said to Mike, 'Wouldn't it be funny if, after he introduces them, Flitwick dives off the stage and crowd-surfs?' We all had a laugh and I went home." On Monday, Davis suddenly found himself in consultation with stunt coordinator Greg Powell. It turns out Newell and Powell had gone to a club over the weekend, seen what Davis had mentioned, and decided to make it a reality. "And I said, 'Pardon?' But I didn't have the heart to tell them I was joking." So the stunt went off, with Flitwick being passed over the student's heads. "And at one point, if you look very closely," Davis advises, "you can actually see my false teeth fly out of my mouth and come back in again!"

FIRST APPEARANCE:
Harry Potter and the Sorcerer's Stone

ADDITIONAL APPEARANCES:
Harry Potter and the Chamber of Secrets
Harry Potter and the Prisoner of Azkaban
Harry Potter and the Goblet of Fire
Harry Potter and the Order of the Phoenix
Harry Potter and the Half-Blood Prince
Harry Potter and the Deathly Hallows – Part 2

HOUSE:
Ravenclaw

OCCUPATION:
Charms professor, Head of Ravenclaw House, Frog Choir conductor

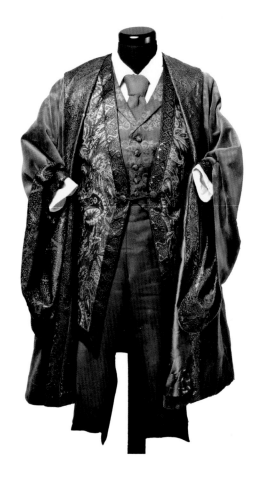

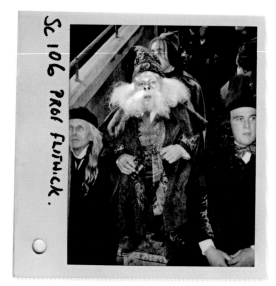

Sc 106 Prof Flitwick.

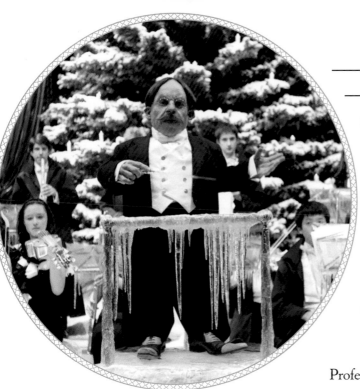

FLITWICK'S WAND

Professor Flitwick's tapered wand has a design that flows seamlessly from the tip to the handle. The shape resembles a stylized stream-lined arrow, with four "feathers" on the fletching end that come together near the darkened tip. In Flitwick's initial appearance as director of the Frog Choir in *Harry Potter and the Prisoner of Azkaban*, he wields a baton worthy of any wand. In *Harry Potter and the Goblet of Fire*, his baton was fashioned from a clear resin that matched the icicle-based decor of the room.

"Do you all have your feathers?"

Professor Flitwick, *Harry Potter and the Sorcerer's Stone*

OPPOSITE BOTTOM AND RIGHT: Flitwick's original robes showcased exotic fabrics, as seen in a continuity shot on the set of *Harry Potter and the Sorcerer's Stone*, a costume reference shot, and a scene from the same film; RIGHT AND ABOVE: Warwick Davis as Flitwick in *Harry Potter and the Goblet of Fire*, a look picked up from the choir master's suit from *Harry Potter and the Prisoner of Azkaban* as seen in Jany Temime's design, sketched by Mauricio Carneiro.

PROFESSOR TRELAWNEY

When asked once to sum up her character, Divination Professor Sybill Trelawney, in one sentence, Emma Thompson simply stated, "Mad as a bucket of snakes." Jany Temime agreed with the actress that Trelawney was mad, "but she has a reason to be mad. She has trouble coping with her life, her job. We could go far in doing something completely absurd and ridiculous because the actor put a sensibility behind it." Thompson felt that Trelawney was someone who hadn't looked in a mirror for a long time, who, in fact, "just couldn't see anything at all," she says. "So I thought if she hasn't looked at herself, if she can't see herself, then she must look all sorts of undone. Buttons missing, clothes a bit raggedy." The actress illustrated her thoughts about Trelawney's look and sent them to director Alfonso Cuarón, who passed them to Temime. Temime felt Thompson's design was "pretty unbeatable." She was clearly influenced by the pervading theme of sight—whether of one's self or of the future—and Temime embellished many of Trelawney's outfits with a form of Indian embroidery called *Shisha*. Shisha embroidery employs mirrors or other reflective material; these are shaped in ovals and circles that create the illusion of Trelawney being covered in eyes.

Thompson worked with the hair and makeup department to generate Trelawney's wild do. "I had this notion of her having hair that just kind of exploded at the top of her head and clearly had not been brushed in a long, long time.

FIRST APPEARANCE:
Harry Potter and the Prisoner of Azkaban

ADDITIONAL APPEARANCES:
Harry Potter and the Order of the Phoenix
Harry Potter and the Deathly Hallows – Part 2

HOUSE:
Ravenclaw

OCCUPATION:
Divination professor

ADDITIONAL SKILL SET:
Seer

BOTTOM: Initial costume designs for Trelawney by Jany Temime included turbans topping the multiple layers of clothing.

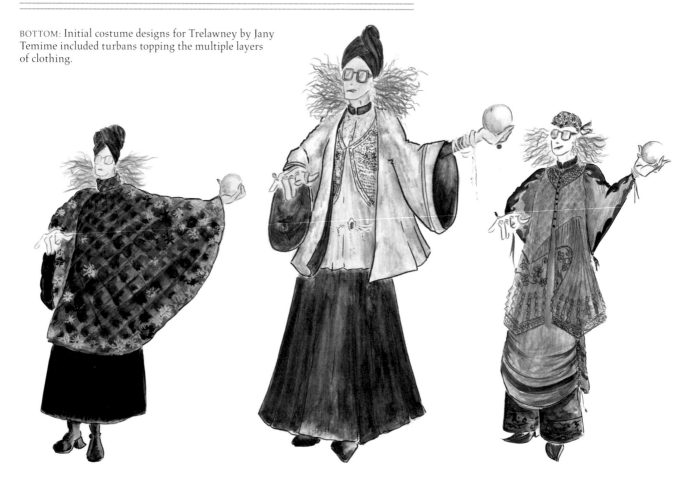

Probably has had squirrels nesting in it at some point," Thompson teases. "One doesn't know what would be found if you went too far into it." Trelawney's huge coke-bottle eyeglasses added the final right touch. "I just knew she had to have these huge eyes," Thompson explains. "The glasses made my eyes enormous, but, of course, they were difficult to see through. So as she's entering the classroom and talking about having 'the sight,' she walks into a table. Her entrance is one of the oldest and cheapest gags in the book, and I take full responsibility for it."

TRELAWNEY'S WAND

Sybill Trelawney's wand, rendered in a single length of wood, has a swirl spiraling around the shaft and a flattened handle. Several of the astronomical symbols on the handle refer to minor planets and asteroids, including Ceres, Hebe, and Melpomene.

> *"Could you please predict something for me?"*
>
> Dolores Umbridge, *Harry Potter and the Order of the Phoenix*

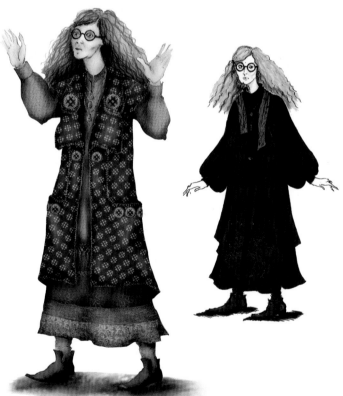

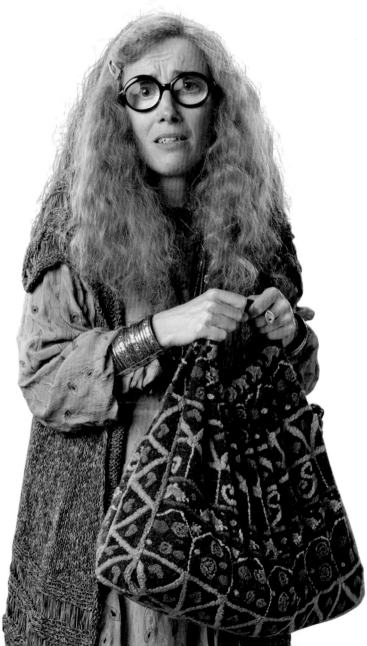

TOP: Shisha embroidery details show how the mirrored pieces added additional texture to Trelawney's robes and shawls; ABOVE: Costume development art sketched by Mauricio Carneiro for *Harry Potter and the Deathly Hallows – Part 2* and *Harry Potter and the Order of the Pheonix;* RIGHT: A publicity photo for *Harry Potter and the Order of the Phoenix.*

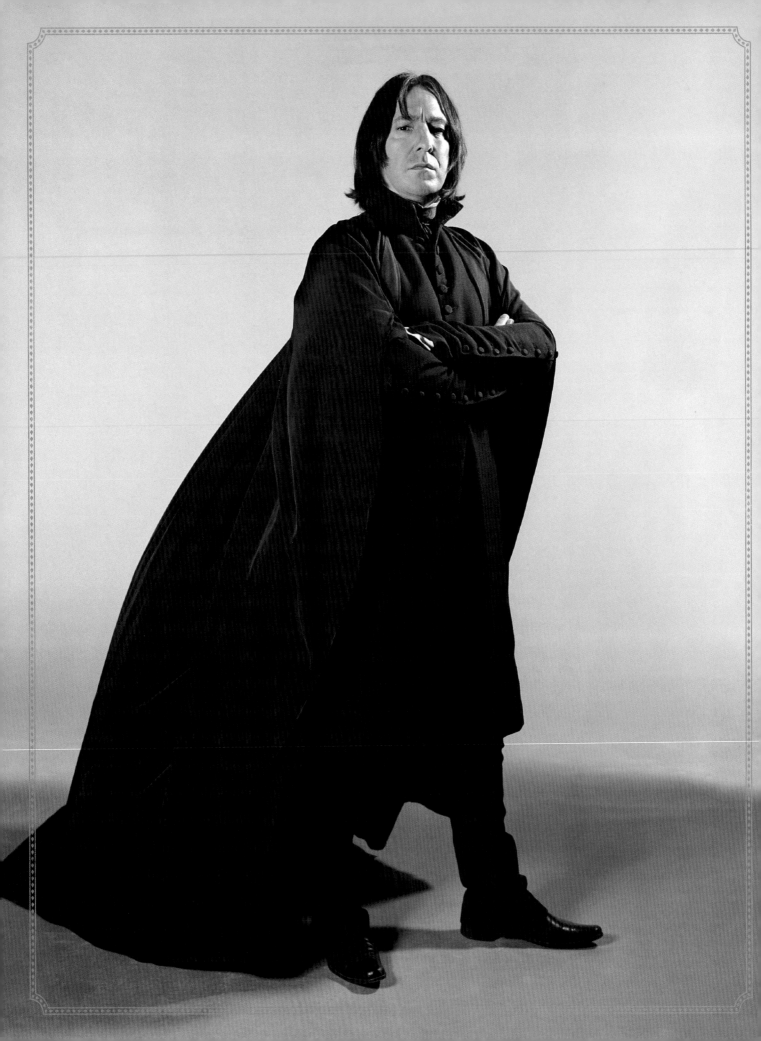

PROFESSOR SNAPE

uring a costume consultation between Alan Rickman and Judianna Makovsky, the actor who plays Professor Severus Snape had two firm requests—the sleeves should be tight, and there should be lots of buttons. "I wanted great care taken in every aspect of the character, both psychological and practical," Rickman explains. "The cut of the hair, the length of the dress robes, the makeup." Rickman considers that his costume is an important part of the very focused life that Snape has led. "You know that he lives a solitary kind of existence, you're not quite sure what the details of that are. He doesn't have much of a social life, and clearly, he's only got one set of clothes," he ends with a laugh. "The costume helped me to understand somebody who lives absolutely alone. Whereas the different costume designers made all sorts of changes through the films to the characters, my costume stayed exactly the same for all eight films. And it helped me, thinking that's the only thing hanging in his wardrobe."

Judianna Makovsky decided that while Dumbledore was very medieval, Snape would follow the Edwardian style. His severe gown is made from traditional academic fabric, ironed until it develops an unusual shine; it is actually a dark blue, which photographs black on film. Buttons run up to his neck, up his long sleeves, and even on his pants over his boots. Snape's robes showcase one very unique element. "We lengthened and split the train so that when he walks, you see these two little tongues that come out, like a snake's forked tongue," she explains. "So in a way, he literally slithers out of a room."

FIRST APPEARANCE:
Harry Potter and the Sorcerer's Stone

ADDITIONAL APPEARANCES:
Harry Potter and the Chamber of Secrets
Harry Potter and the Prisoner of Azkaban
Harry Potter and the Goblet of Fire
Harry Potter and the Order of the Phoenix
Harry Potter and the Half-Blood Prince
Harry Potter and the Deathly Hallows – Part 1
Harry Potter and the Deathly Hallows – Part 2

HOUSE:
Slytherin

OCCUPATION:
Potions Master, Defense Against the Dark Arts professor (sixth year), Head of Slytherin House, Headmaster of Hogwarts (seventh year)

MEMBER OF:
Death Eaters, Order of the Phoenix

PATRONUS:
Doe

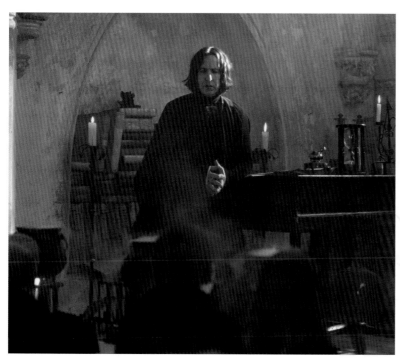

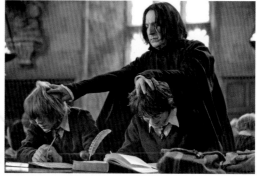

"Always."

Severus Snape, *Harry Potter and the Deathly Hallows – Part 2*

OPPOSITE: A publicity photo for *Harry Potter and the Sorcerer's Stone*; ABOVE: Snape's first Potions class with *Harry Potter in Sorcerer's Stone*; RIGHT: Ron Weasley and Harry Potter receive a warning from Snape in *Harry Potter and the Goblet of Fire*.

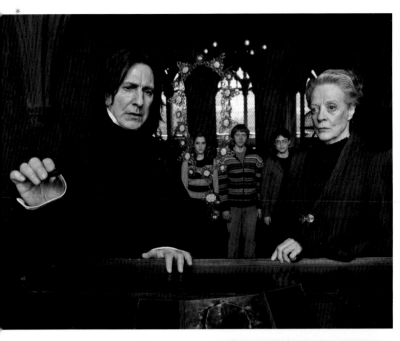

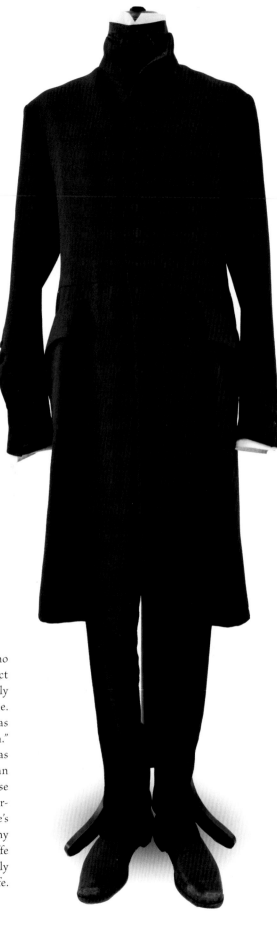

Jany Temime calls the design of Snape's outfit "a winner. He's a man who never explodes out of his clothes, so he must wear something extremely strict and precise." Rickman concurs. "He lives within very tight confines—physically as well as emotionally." He also offers a practical appreciation for his wardrobe. "Leavesden Studios didn't have the best heating system in the world, so I was more fortunate than others with my costume, which was always pretty warm."

Alan Rickman would arrive on set in full costume and makeup. "I was very aware that the kids were confronted by the Snape-ness of me," Rickman explains, "so it took a while for them to know that there was somebody else underneath it all." Rupert Grint remembers that Rickman often stayed in character between takes. "I don't mean he was evil or anything," says Grint. "But he's quite intimidating." Snape is very mean to Harry, who does not understand why until the story is complete. As they started working together, Daniel Radcliffe admits that "I was constantly having to remind myself: 'It's only a film, it's only a film, it's only a film . . . nothing's real,' but it was terrifying." says Radcliffe. "Alan Rickman was so fantastic as Severus Snape, I was freaked."

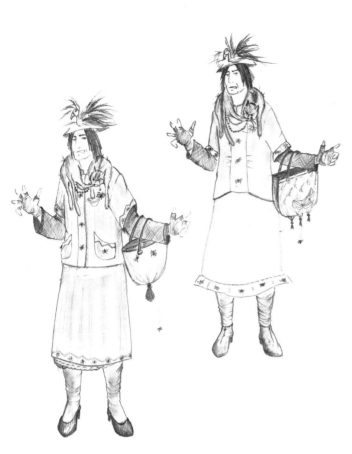

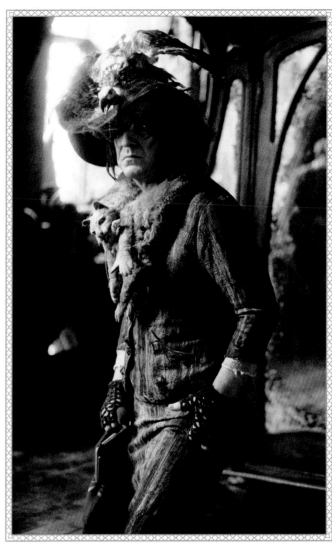

SNAPE'S WAND

Severus Snape's slim wand is fashioned in a dark, ebony black, with an intricate, unique design that is doubled on both sides of the handle. The majority of wands used for filming were cast in resin or a urethane rubber; wood versions were used for close-ups. Actor Alan Rickman is one of the few actors who was able to keep one of the original wood wands he used on set.

OPPOSITE TOP LEFT: Professors Snape and McGonagall inspect the cursed necklace in *Harry Potter and the Half-Blood Prince*; OPPOSITE CENTER LEFT: Snape's buttoned-up pants leg; OPPOSITE RIGHT: The professor's Edwardian suit never changed through the course of eight films; TOP AND ABOVE: Costume sketches for the Boggart-version of Snape wearing Neville Longbottom's grandmother's clothes in *Harry Potter and the Prisoner of Azkaban* (design by Jany Temime, sketches by Laurent Guinci) and the realized version from the film; LEFT: A closer look at the "forked tail" of Snape's robes designed by Judianna Makovsky for *Harry Potter and the Sorcerer's Stone*.

PROFESSOR QUIRRELL

Harry Potter and the Sorcerer's Stone costume designer Judianna Makovsky's concept for all the Hogwarts professors was to evoke formal British school attire, which incorporates suits and ties under the teachers' robes. For Defense Against the Dark Arts Professor Quirrell's outfit, Makovsky was tasked with adding a turban, which Quirrell, played by Ian Hart, wears to hide the fact that he is sharing his body with the disembodied form of Lord Voldemort. "The book was specific that he wore a turban," says Makovsky, "but I was concerned that the turban didn't look too exotic or out of place." She moved away from using Middle Eastern– or Indian-style turbans, which are traditionally closer to the head in back and raised to a more pointed form. Instead, Makovsky chose a design from the Renaissance, as the wrappings are larger and less constricting so it wouldn't seem obvious that Quirrell was hiding something. In order to downplay the character, who is purposely trying not to be conspicuous, she chose flat blacks and browns for his suits, which suggested a shy person and an impoverished status.

Actor Ian Hart received a funny shock when he went to research the character before meeting with the producers and casting director of *Harry Potter and the Sorcerer's Stone*. "I'd never read any of the books, so I went to a local bookshop," he explains, "and they gave me the second book, *Harry Potter and the Chamber of Secrets*." Professor Quirrell, of course, doesn't make it past the first book. "I was looking through it, thinking 'Where's my character? It can't be that big a part, as I can't find it!'"

APPEARANCE:
Harry Potter and the Sorcerer's Stone

HOUSE:
Ravenclaw

OCCUPATION:
Defense Against the Dark Arts
professor (first year)

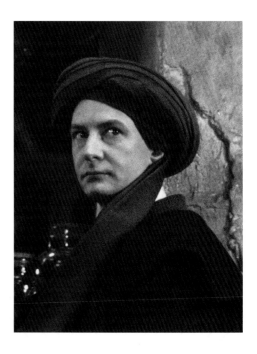

PROFESSOR QUIRREL

WIZARD GOWN

LINING TO WIZARD GOWN

CAPE

TIE

JACKET

MRS E IN COAT

TURBAN

FABRIC SWATCHES 02/02/2001

ABOVE LEFT: A close-up of Quirrell's plain-colored coat for *Harry Potter and the Sorcerer's Stone*; ABOVE RIGHT: Costume swatches on a reference sheet; RIGHT: The Renaissance-inspired turban worn by Quirrell hides a dark secret; OPPOSITE TOP LEFT: The turban in the costume shop; OPPOSITE TOP RIGHT: A digital rendition of Voldemort's face positioned on the back of Quirrell's head; OPPOSITE BOTTOM: An early depiction of the snakelike face of Lord Voldemort by visual artist Paul Catling.

"Who would suspect p-p-p-poor st-t-t-stuttering Professor Quirrell?"

Professor Quirrell, *Harry Potter and the Sorcerer's Stone*

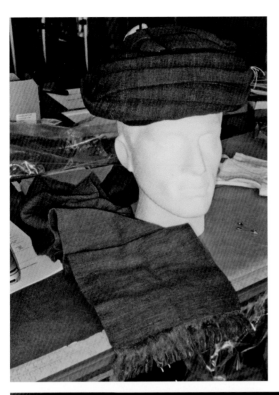

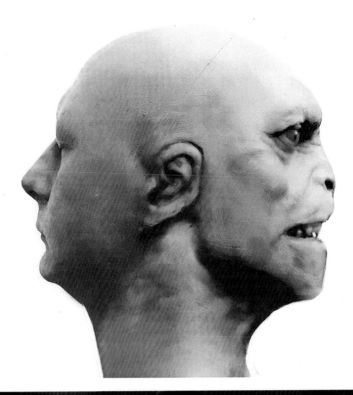

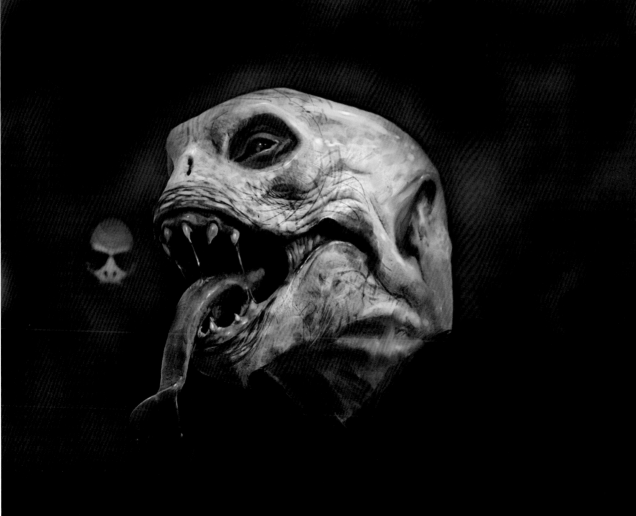

PROFESSOR LOCKHART

When Kenneth Branagh came in to audition for the role of Professor Gilderoy Lockhart, "he was perfect," David Heyman recalls. "Ken is the consummate actor. And yet he was comfortable playing the narcissist and the buffoon. His performance was heightened, but it had real truth."

Daniel Radcliffe (Harry Potter) offers his own opinion. "Lockhart is an egotist with thousands of pictures of himself, and he's a show-off and a fraud," says Radcliffe. "Girls love him, and boys hate him, because they know that something is not quite right. He's cringeworthy. Kenneth Branagh, on the other hand, is the nicest man on earth, and one of the funniest people you'll meet."

Lockhart's attention to how he appears is reflected in his wardrobe, of course. For that, "we looked at references of old movie actors and cinema idols from the twenties through to the fifties," says *Harry Potter and the Chamber of Secrets* associate costume designer Michael O'Connor. "Anyone who's read the book knows that Gilderoy is a very vain man," adds *Chamber of Secrets* costume designer Lindy Hemming, "and has created this fabulous persona for himself. He wants to create a large and glorious impression, and sweeps about in gowns that are colorful." However, "Lockhart was known for wearing lilac and pink and powder blue, and these pastels weren't within the color scheme of the Harry Potter films," continues Hemming. So, the filmmakers used grayish blues, golden mustards, and brownish pinks that would fit the overall palette of the film but still make Lockhart look brighter than the characters around him. "We tried to have as much fun as we could with the look and clothes of the character," says Kenneth Branagh. "Gilderoy is something of a dandy, and he struts like a peacock. He feels himself to be terrifically important, so he's a delicious character to play." Lockhart wore lush-looking fabrics—gold-embroidered velvets, silk damasks, brocades, and moirés—and sported an extensive collection of matching capes and cravats. Branagh's makeup included a set of perfect, sparkling false teeth, and wigs that needed to look like wigs, as Lockhart is seen packing away a hairpiece in his attempt to flee Hogwarts. He was also outfitted in an array of exotic outfits to create the book covers for his many best-selling books and the framed photos strewn about his classroom.

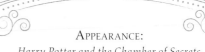

APPEARANCE:
Harry Potter and the Chamber of Secrets

HOUSE:
Ravenclaw

OCCUPATION:
Defense Against the Dark Arts professor (second year)

MEMBER OF:
Order of Merlin, Third Class; Honorary Member of the Dark Force Defense League

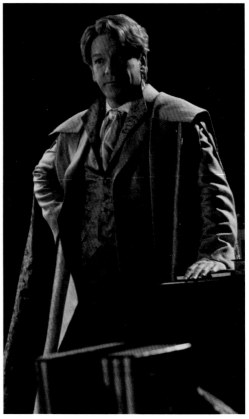

RIGHT: A collection of books chronicles a series of adventures Lockhart never actually had, designed by Miraphona Mina and Eduardo Lima for *Harry Potter and the Chamber of Secrets*; FAR RIGHT: The professor in his classroom; OPPOSITE TOP LEFT AND CENTER: Costume reference photos; OPPOSITE MIDDLE LEFT: Lockhart attempts the *Brachium Amendo* Spell on Harry Potter's arm; OPPOSITE TOP RIGHT: A continuity sheet explains the proper way to tie Lockhart's cravat; OPPOSITE BOTTOM RIGHT: Lockhart's duelling costume.

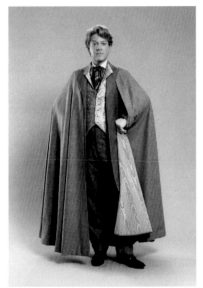

HARRY POTTER
The Chamber Of Secrets

COSTUME CONTINUITY REPORT

CHARACTER:	ACTOR:
GILDEROY LOCKHART	KENNETH BRANAGH

COSTUME NUMBER: 2

SCENES: 42 A + B	STORY DAY: 7

LOCATION:
INT: LOCKHARTS CLASSROOM

DESCRIPTION:
ROBE : GOLD SLEEVES WITH FLORAL FACINGS, TURNED BACK WHILST SEATED
COAT : 3/4 FROCK COAT, NO BUTTONS
WAISTCOAT : GOLD FLORAL PATTERN SILK BROCADE , ALL BUTTONS FASTENED
REVERS TURNED BACK (NOT FLAT) OUTSIDE OF COAT AND ROBE
TROUSERS : MUSTARD CROSS WEAVE WORN WITH BRACES

SHIRT : IVORY , FIXED CHARGE COLLAR , TWO TOP BUTTONS FASTENED
CUFFS WITH GOLD MONOGRAMMED LINKS AS BELOW
CRAVAT : IVORY SILK BROCADE WITH LARGE BOW AS BELOW

BOOTS : LIGHT BROWN ELASTIC SIDED , RUBBERISED SOLE

NOTES:

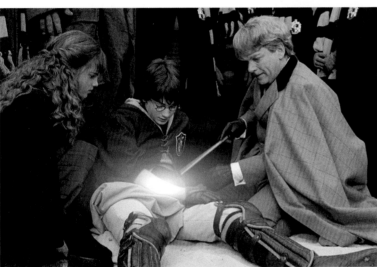

LOCKHART'S WAND

Gilderoy Lockhart's wand may appear simple, as do most of the wands for the first two films, but it was finished with a lily design at the top. In a reverse from many of the wands, the shaft was constructed from a light wood and the handle was darker. Actor Kenneth Branagh (Lockhart) gave great consideration to his wand moves for his duel with Severus Snape in *Harry Potter and the Chamber of Secrets*. "If you are down the other end of the platform from Alan Rickman," says Branagh, "and he's got a wand, you've got to be very good to get noticed down at your end!"

"Let me introduce you to your new Defense Against the Dark Arts teacher. Me!"

Gilderoy Lockhart,
Harry Potter and the Chamber of Secrets

PROFESSOR LUPIN

As David Thewlis began filming his role as Defense Against the Dark Arts Professor Remus Lupin for *Harry Potter and the Prisoner of Azkaban*, he had the impression that "the part was just a one-off," as Lupin does not appear in the fourth book, *Harry Potter and the Goblet of Fire*. But then he heard rumors that Lupin would be coming back. When *Harry Potter and the Order of the Phoenix* was published halfway through the third film's production, Thewlis stood in line among the young witch-and-wizard attired fans at his local bookstore's midnight party. "I picked up a copy, and while standing in line started leafing through to see if Lupin was mentioned. And sure enough, I saw he was, quite early on." Thewlis was delighted that he would be able to return for *Harry Potter and the Order of the Phoenix*, and then went to the end of the book to see if his character made it all the way through, as there were rumors that one major character did not. "I saw that Lupin made it, but accidentally caught sight of Sirius Black being talked about in the past tense." As fate would have it, Thewlis bumped into his neighbor Gary Oldman the next morning, who also had a copy of the book but hadn't sneaked a look at the ending. "So, Gary asks if I'd seen the book, and I was like, yeah, oh yeah, yeah. And he says, 'We've got a lot of work to do, mate.' Oh yeah, yeah, okay. I didn't have the heart to tell him he wasn't going to make it all the way through."

In *Harry Potter and the Prisoner of Azkaban*, it's discovered that Lupin is a werewolf, an iconic "movie monster" that Thewlis and director Alfonso Cuarón were determined to give a fresh approach. Cuarón saw Lupin as "your favorite uncle who is hiding a horrible disease. Instead of being healthy and powerful, he's sick. It's tragic, not scary." Thewlis agreed, and opted that he only had to address the transformation when Lupin actually transformed. Otherwise, he says, "Lupin is that favorite teacher who is a little more social and friendly than would normally be the case." Thewlis was inspired by several of his former teachers as well as beloved cinematic professors such as in *Good-bye, Mr. Chips*.

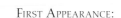

FIRST APPEARANCE:
Harry Potter and the Prisoner of Azkaban

ADDITIONAL APPEARANCES:
Harry Potter and the Order of the Phoenix
Harry Potter and the Half-Blood Prince
Harry Potter and the Deathly Hallows – Part 1
Harry Potter and the Deathly Hallows – Part 2

HOUSE:
Gryffindor

OCCUPATION:
Defense Against the Dark Arts professor
(third year)

MEMBER OF:
Order of the Phoenix

ADDITIONAL INFORMATION:
Werewolf (Moony)

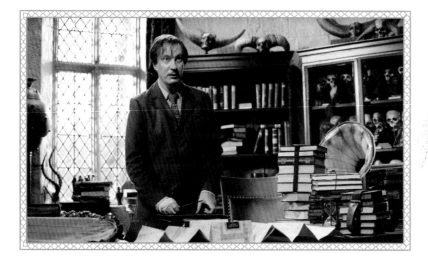

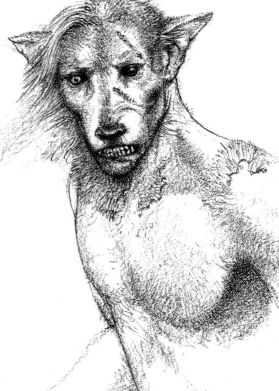

ABOVE: Lupin with the Marauder's Map; RIGHT: Development artwork of a werewolf by Wayne Barlowe; OPPOSITE, CLOCKWISE FROM TOP: Harry Potter accompanied by Hedwig (Gizmo) spends time with Lupin; a publicity photo; sketches by Mauricio Carneiro and fabric swatches for Lupin's simple suit—all for *Harry Potter and the Prisoner of Azkaban*.

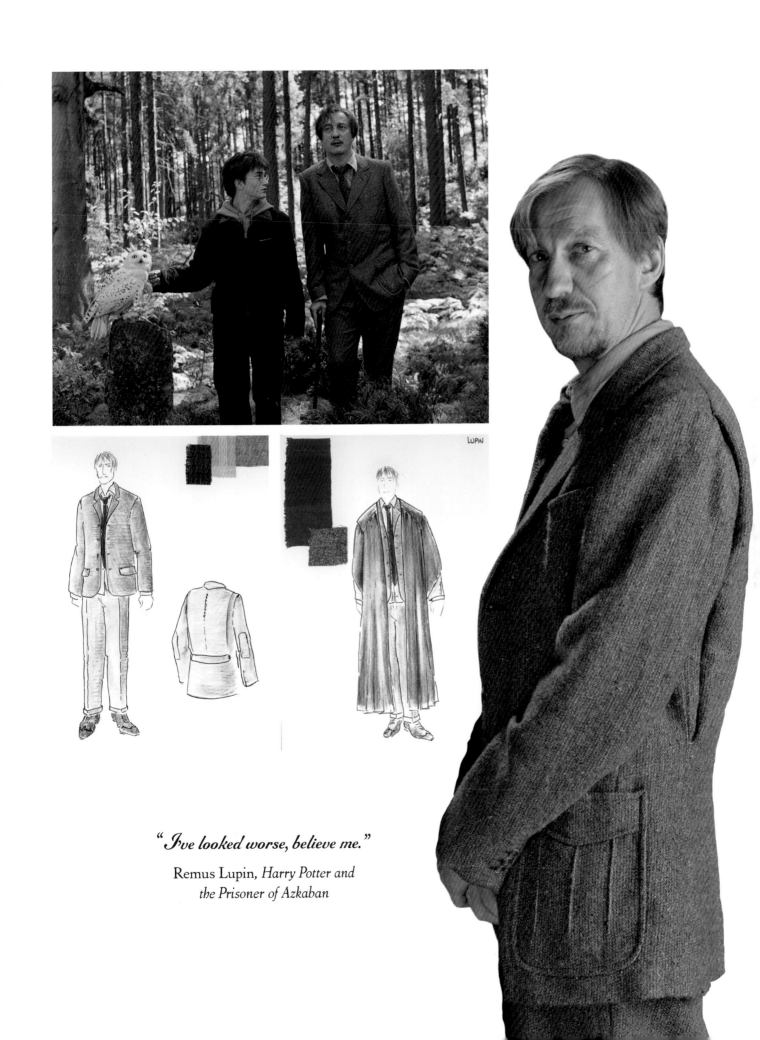

"*I've looked worse, believe me.*"

Remus Lupin, *Harry Potter and
the Prisoner of Azkaban*

FINAL STAGE **3** COSTUME 9.

HARRY POTTER
& THE PRISONER OF AZKABAN
COSTUME CONTINUITY

CHARACTER	PROF LUPIN		ACTOR:	DAVID THEWLIS.

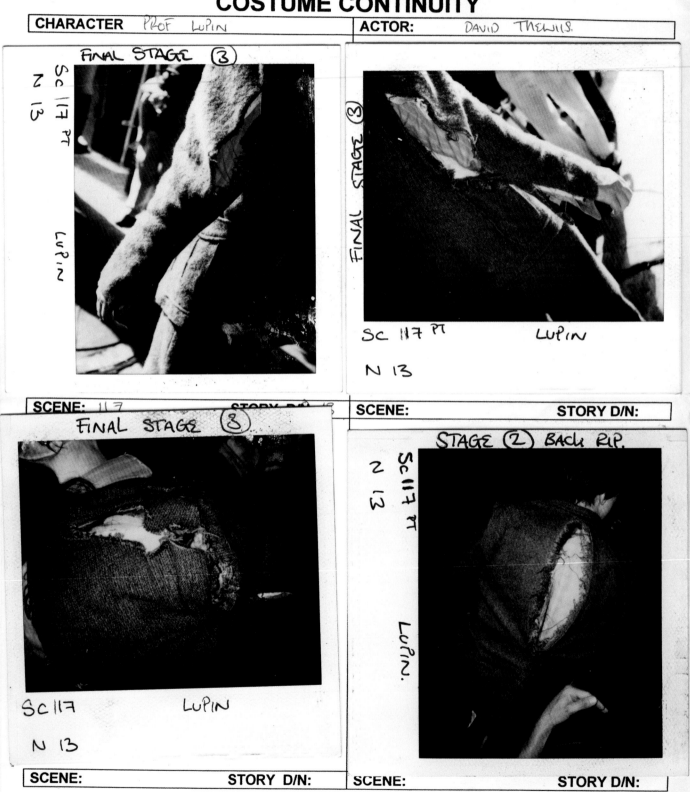

FINAL STAGE ③

SC 117 PT

N 13

LUPIN

FINAL STAGE ③

SC 117 PT LUPIN

N 13

SCENE: 117	STORY D/N:

FINAL STAGE ③

SC 117 LUPIN

N 13

SCENE:	STORY D/N:

STAGE ② BACK RIP.

SC 117 PT

N 13

LUPIN.

SCENE:	STORY D/N:

Remus Lupin's illness has taken a toll on him in many ways, one being the state of his wardrobe. "It is written that Lupin's clothes are of poor quality and shabby," says Jany Temime. "So his suit and academy gown are drab and a bit threadbare. They're not like any of the other teachers'." Lupin is still a very "tweedy professor," she continues. Regardless of the condition, Lupin's outfits are an example of her philosophy toward dressing the wizarding world. "In all their clothes," she explains, "we want what I think of as traditional construction to them. Lupin was given long, pointed sleeves, and on his jacket, the collar has a point on the back. His pockets have points on them as well. He is a typical English wizard."

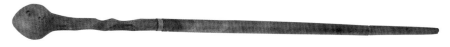

LUPIN'S WAND

Remus Lupin's wand was crafted from olivewood, and its design "was quite gentle," describes Pierre Bohanna. "It's really the closest to a conductor's baton in its shape." The prop makers strove to give each wand a sense of timelessness. "They should look period, or at least look well used," adds Bohanna. "It should be difficult to judge how old the wands are." Actor David Thewlis hoped to take his wand home as a souvenir, but noted how careful the crew was to store the wands properly and safely after each scene. "It would have been like trying to take a nugget of gold out of a bank," he laughs.

OPPOSITE: Continuity shots of the rips and tears in Lupin's clothing, taken during his transformation to a werewolf; THIS PAGE: Visual development artwork of Lupin in his werewolf form by Wayne Barlowe.

PROFESSOR MOODY

Alastor Moody's teaching style is a one-eighty from previous Defense Against the Dark Arts teachers. Moody is more about "tough love," says actor Brendan Gleeson. "He wants them to face the fact that evil exists; they'd better know what they're getting themselves into." But Moody's on their side, he avers, which is apparent in his performances in *Harry Potter and the Order of the Phoenix* and *Harry Potter and the Deathly Hallows – Part 1*. "I think he's rather comforting to have around once we learn he was brought in to protect Harry." Gleeson does make the most of the ex-Auror's formidable personality. "Moody is a gunslinger with a wand. He's obviously suffered terrible trauma. This guy has gone past a sell-by date in the sense that he was out there at the cutting edge. And so he's become quite paranoid now, but that doesn't mean that everybody isn't out to get him, because they are!"

Jany Temime agrees with Gleeson's gunslinger analogy. "My inspiration was Spaghetti Westerns," she says. "Instead of a horse, the man rides into the sunset on his broomstick. And the man sleeps in his coat, he *lives* in his coat; all of his possessions are in that coat." "That coat" was inspired by a 1940s war coat, replicated in dark khaki and made to appear as if it was just as old. Breakdown artist Tim Shanahan explains that the process begins with blowtorches. "Any fiber on a coat has a fuzz to it that goes flat and shiny as it is gradually worn away, whether it's stitching or the entire coat itself. We use blowtorches to lightly burn off the tops of the fibers." Bleach is applied to lighten certain areas, or tar and paints are added to create stains. The coat is sanded and then stained again. The material is ripped and frayed with knives and scruffers—the name of a wire brush invented just for this task. Varnish flattens the shine of buttons, buckles, and zippers, which are also sanded down. Pockets are wetted and weighted down throughout this process, to get them to be baggy and saggy. This process is done to not only the actor's coat, but to their stunt doubles', and made in multiple versions due to wear and tear during filming. It took about eighty hours to create just one coat for "Mad-Eye" Moody, and seven coats were needed for the actor and his stunt doubles.

FIRST APPEARANCE:
Harry Potter and the Goblet of Fire

ADDITIONAL APPEARANCES:
Harry Potter and the Order of the Phoenix
Harry Potter and the Deathly Hallows – Part 1

OCCUPATION:
Ex-Auror, Defense Against the Dark Arts professor (fourth year)

MEMBER OF:
Order of the Phoenix

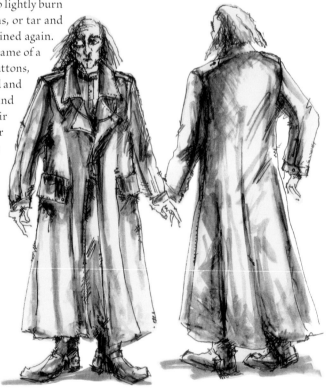

LEFT: Close-up of the small bottle in Moody's coat pocket, which holds Polyjuice Potion, *Harry Potter and the Deathly Hallows – Part 1*; ABOVE: Costume sketches by Mauricio Carneiro; OPPOSITE: Gleeson as Bartemius Crouch Jr. as Professor "Mad-Eye" Moody in "that coat" in a publicity shot for *Harry Potter and the Goblet of Fire*.

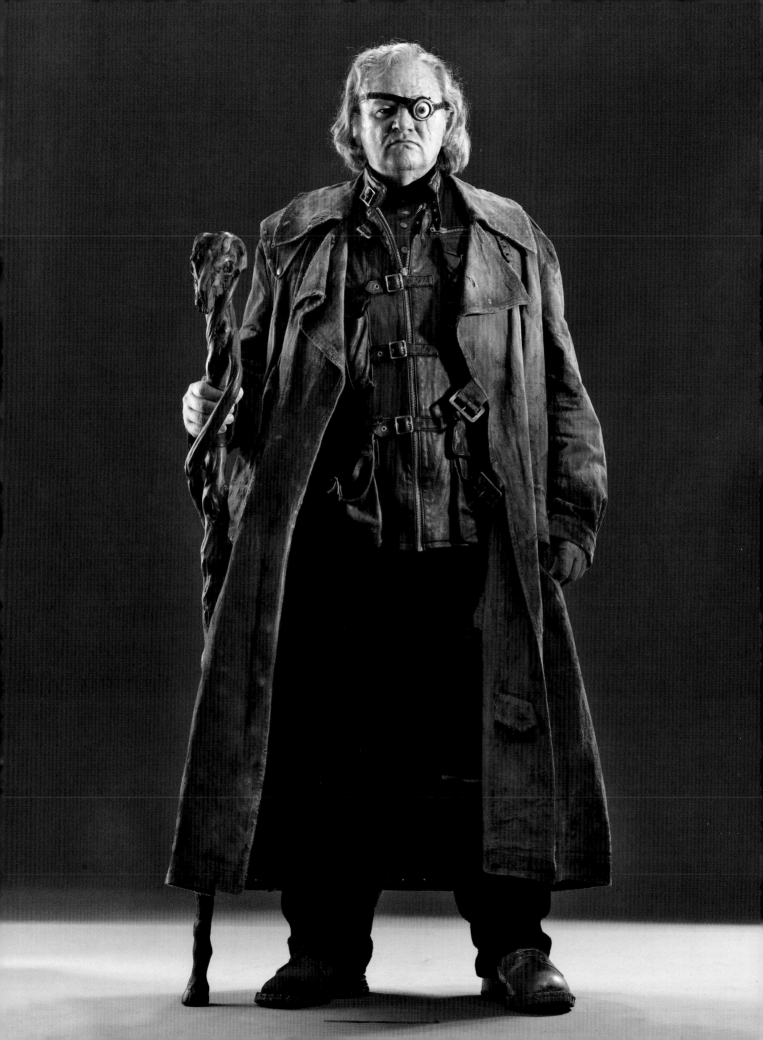

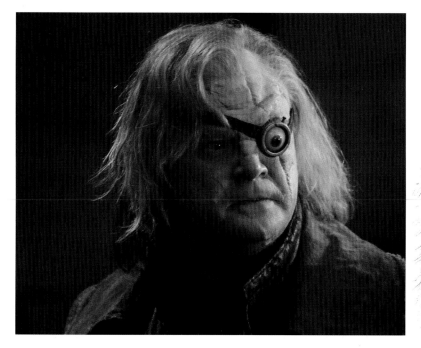

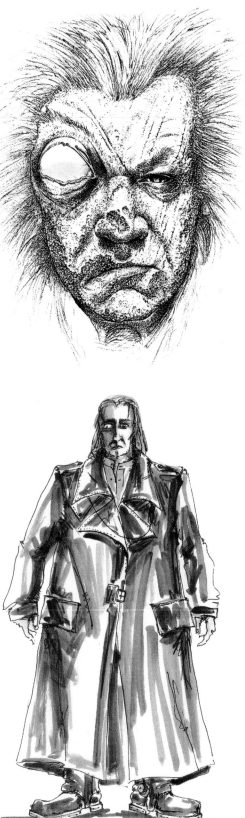

Moody's signature feature—his "mad-eye"—is housed in a silicone prosthetic over which is strapped a brass "porthole"-shaped framework. The initial idea was to composite the eye digitally onto the actor's face. "We really fought against that," says Nick Dudman, "because we wanted it to be something Brendan Gleeson could work with even though he's not actually operating the eye." The challenge was to attach the eye in such a way that it didn't *look* attached. "We came up with the logic that he'd had to have had a massive injury where he'd lost his eye," says Dudman, "and so there is a build-up of scarring over that side of his face. And then Chris Barton, my animatronic designer, came up with the idea of placing a shell over the actor's eye that has a very small magnet—it's less than three millimeters thick—right behind the pupil of the mechanical eye that moves around via radio servers." If the magnet eye was pulled around too far, it would hit the side of its holder, breaking the magnetic link, and pop off. "And occasionally the eye line didn't quite match between the actor's, so they shifted it into place in postproduction," admits Dudman, "but it was a nice, simple, practical answer."

Built-up in several pieces, the prosthetic has channels that run through it to hide wires attached to the radio-controlled eye. Covering over the embedded wires are straps that also serve to secure it. The makeup and hair department then applies a wig over the prosthetic. "We fashioned the wig in panels that fit over all the mechanics," says Eithne Fennell. "We needed to create separate sections of hair because if anything went wrong with the eye, a panel could flap open so they could fix it and then we would put it back on again."

The "Mad-Eye" Moody seen in *Harry Potter and the Goblet of Fire* is actually a "Polyjuice-Potioned" Bartemius Crouch Jr. "Moody is a character who is played by one actor," explains director Mike Newell, "who contains another actor inside him." Crouch Jr. is played by David Tennant, who compares being cast in a Harry Potter movie with "being called up to play for the England football squad—you don't necessarily expect it, but when it comes, it's the kind of honor you just can't turn down." Although a small part in the film, Tennant's performance is memorable, not the least for the deranged Death Eater's snakelike tongue-flick tic. "We needed something that would attach to both characters," explains Newell. Given this directive, Tennant improvised the quirk, which Brendan Gleeson then added to his portrayal.

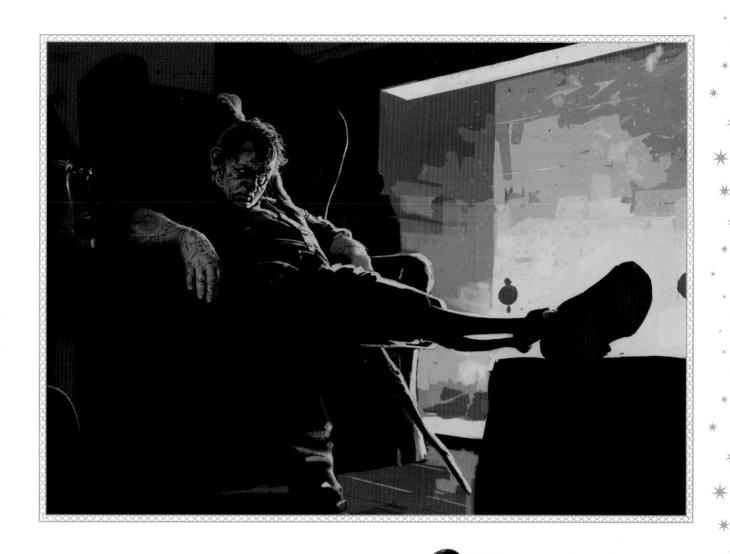

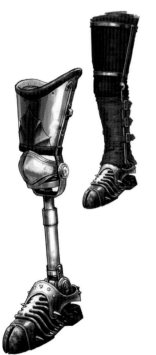

"*Ex-Auror, Ministry malcontent, and your new Defense Against the Dark Arts teacher. I'm here because Dumbledore asked me. End of story, good-bye, the end!*"

Professor Moody, *Harry Potter and the Goblet of Fire*

MOODY'S WAND

Alastor Moody actually had four wands that he used, including one specifically designed to repair his silver leg in *Harry Potter and the Goblet of Fire*. "I asked if it could look like a replica of a spire in Dublin," says actor Brendan Gleeson. "It was used only once, but if I could have one, that would be the one I always cast my eye on, so to speak." Moody's main wand sported a round end that resembled the handle of his walking stick, and was banded in silver and bronze. The wand is shorter than most, seemingly having seen a lot of action.

OPPOSITE TOP LEFT: Unit photography from *Harry Potter and the Goblet of Fire*; OPPOSITE TOP RIGHT: Early artwork of "Mad-Eye" by Wayne Barlowe; OPPOSITE BOTTOM RIGHT: A costume sketch by Mauricio Carneiro; LEFT: Moody's prosthetic leg as fashioned by Adam Brockbank; TOP: Concept art by Adam Brockbank.

PROFESSOR UMBRIDGE

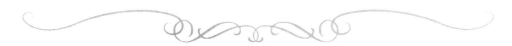

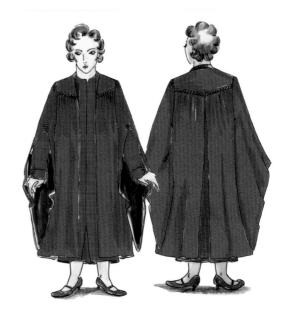

After *Harry Potter and the Order of the Phoenix*, the fifth Harry Potter book, was published, a friend of Imelda Staunton's phoned her to suggest there was a part in it Staunton should play. "So I read it again," recalls Staunton, "and the description was 'short, fat, ugly, toad-like woman.' Oh, thanks for that!" But Staunton recognized that Dolores Umbridge is "just a delicious baddie. And I wouldn't have to spend too much time hanging from a crane."

Staunton wondered initially if Umbridge would look as described in the book. "Will she be literally toad-like, and would I have prosthetics?" No prosthetics are used, but Staunton did ask for something extra to be added to the character's look. "She wanted to give her a big bottom," says Jany Temime. "She's actually a very thin woman." Padding was added front and back that inspired Staunton to create a distinctive walk, "like a duck," laughs Temime. Umbridge's physicality is stiff, rehearsed, almost robotic, at odds with the impression she's trying to create of being nice. "And she's not a real teacher," Temime explains. "She doesn't want to look like a teacher. She wants to look like a woman who is sent from the Ministry." Temime created a silhouette that is prim and elegant, with peculiar touches of girlishness. "I wanted her costumes to appear serious, but always with one detail that was just a bit too much. So maybe the bow is too big or the combination of fabrics is crude. Imelda had a strong opinion about what she wanted," she concludes, "but luckily I had the same opinion."

Umbridge's ensembles are accessorized with brooches, pins, and rings—all bearing an image of a cat, like the plates on the walls of her office. The character is written as having a decidedly pink theme to her wardrobe—even her wizard robes are pink—and Temime appreciated how Rowling had put one of her hardest-edged characters in a very soft color. She seized the opportunity to use the contradiction to the character's advantage. Umbridge is initially attired in mild pink dresses that become darker and darker until her last outfit, which is fashioned in an almost electric fuchsia Temime deemed "acidic and aggressive." To stress the incongruity even more, fabrics with soft textures were used—handwoven tweeds, velours, velvets, and angora from Paris. Staunton and Temime were again in complete agreement about this. "I wanted her to appear soft," says Staunton, "which I discussed with Jany. I didn't want any hard edges; I thought it was quite important for her to have a softness and a warmth to her look. What's more frightening than a little round woolly person who turns out to be not very nice? She's so dedicated to helping these children to see the light. Or to see the pink, I think."

RIGHT AND OPPOSITE TOP LEFT: Costume designs by Jany Temime show not only the outfit but a progression of ever-darkening pinks, sketches by Mauricio Carneiro; OPPOSITE LEFT: A simple outfit with girlish flourishes and ubiquitous cat jewelry as worn by Imelda Staunton in a publicity photo for *Harry Potter and the Order of the Phoenix*; OPPOSITE MIDDLE RIGHT: Fabric swatches.

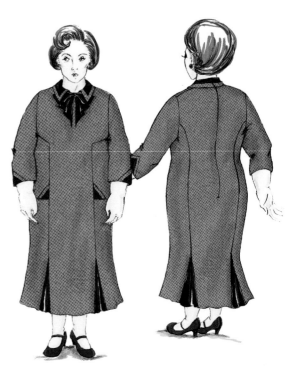

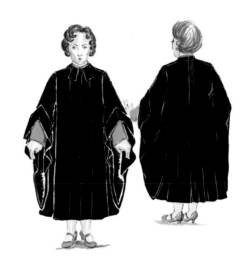

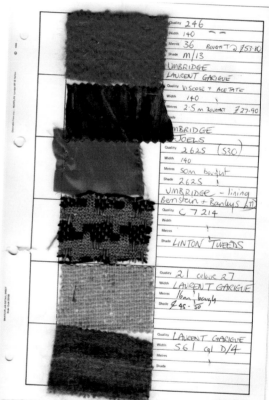

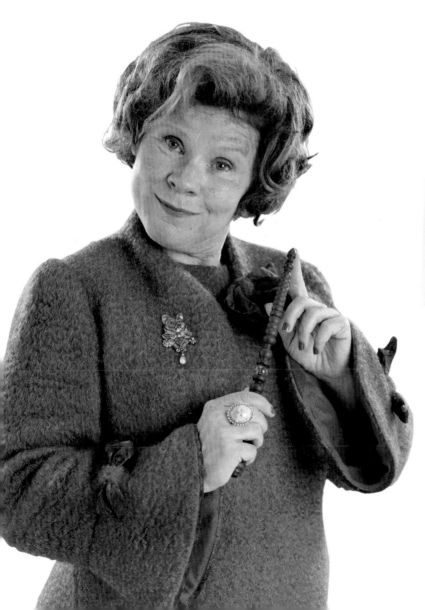

UMBRIDGE'S WAND

Not surprisingly, Dolores Umbridge's wand has a bit
of pink in it. The wand as a whole is designed with a
series of very ornate turns, and a very pointed end,
but within the middle is a round, deep pink jewel. The
wand was created in purple mahogany wood but cast
in a clear color of resin before it was stained.

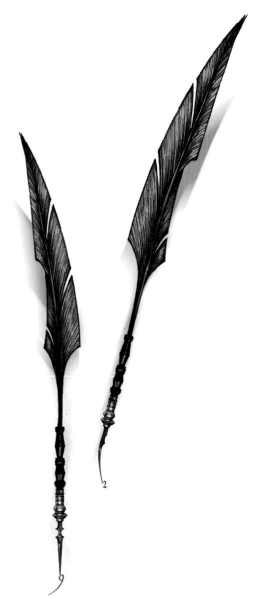

As Dolores Umbridge monitors the fifth-year students' O.W.L. (Ordinary Wizarding Level) exams, disturbing noises are heard outside the Great Hall, so Umbridge opens the doors to investigate. Suddenly, Fred and George Weasley fly in on their brooms, scattering the students' test papers and setting off Weasleys' Wizard Wheezes fireworks throughout the room. For their big finale, a long Chinese dragon firework pursues Umbridge from one end of the Hall to the other, "swallowing" her with its luminescent jaws. The fireworks also smash into and shatter the Educational Decrees that Umbridge has hung outside the Hall. When the pandemonium ceases (and the Weasley twins leave Hogwarts with a flourish only they could devise), Umbridge stands among the ruined rules, singed with fireworks ash, smoke rising from her pink ensemble.

To create the after-effects of the fireworks barrage, Imelda Staunton wore a vest underneath her dress that was attached to a big, long tube that came out the back. When smoke flowed into the tube, it eventually came out through her costume. The dress was also distressed with wire brushes, paint, and dirt for its scorched appearance. Fortunately, the proclamation boards that fell on Umbridge were made from foam for the scene.

TOP AND ABOVE: Pink pervades Umbridge's wardrobe, from a pair of pussycat adornments to a pair of pink pumps; RIGHT: Designs for Umbridge's Dark Quill; OPPOSITE: Costume designs by Jany Temime, sketched by Mauricio Carneiro, showcase ever-deepening hues of pink, from fuchsia to magenta.

*"Study hard and you will be rewarded.
Fail to do so, and the consequences
may be severe."*

Professor Umbridge, *Harry Potter
and the Order of the Phoenix*

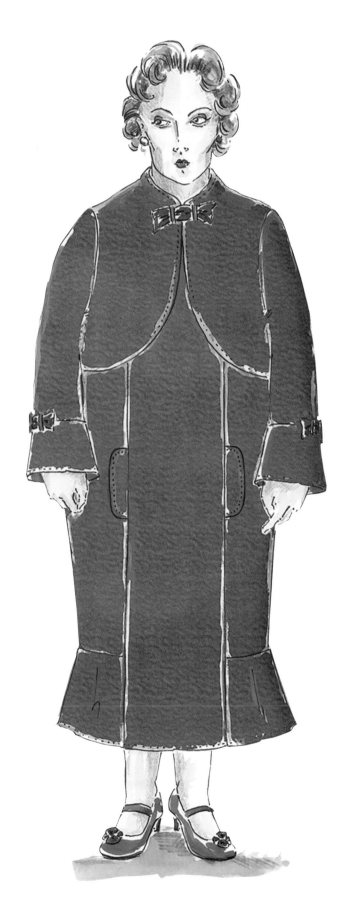

PROFESSOR SLUGHORN

By the time Jim Broadbent joined the Harry Potter films as Potions Professor Horace Slughorn, he had already played a rich diversity of roles in more than one hundred films. *Harry Potter and the Half-Blood Prince* offered him a new acting challenge. "When we first meet my character," he explains, "I am disguised as an armchair." Did Broadbent have anything in his long career he could draw upon? "I did a voice-over of a lavatory seat once. But this is my first real chair." Jany Temime sourced the lilac-colored material that transforms from upholstery into pajamas, but this was just the first piece of Slughorn's extensive wardrobe.

Temime believes that Slughorn isn't the clotheshorse that Dumbledore is, but is "somebody who just has the right outfit for the right occasion." She feels that he has been holding on to his clothes for twenty-five years or so, and that though they have remained fashionable, they are a bit worn and shabby. "He just keeps wearing them, and perhaps that is to recapture his glory," she muses. "Once upon a time these clothes were quite beautiful, but now they're so used, buttons are hanging off, his shoes are damaged, the fabric has been mended again and again." We are offered a chance to see the clothes in their original condition, when a memory of his time teaching Tom Riddle is seen through the Pensieve. Jim Broadbent was padded to give him girth and age, which was removed for his "younger" scenes.

FIRST APPEARANCE:
Harry Potter and the Half-Blood Prince

ADDITIONAL APPEARANCE:
Harry Potter and the Deathly Hallows – Part 2

HOUSE:
Slytherin

OCCUPATION:
Potions Master

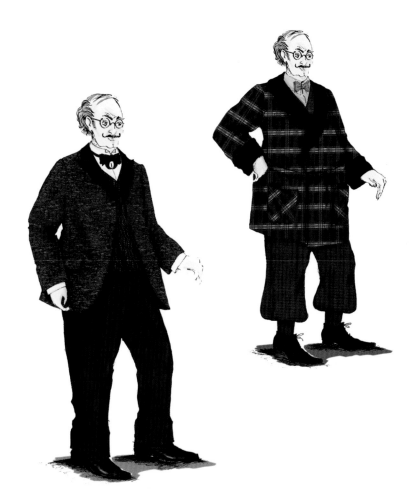

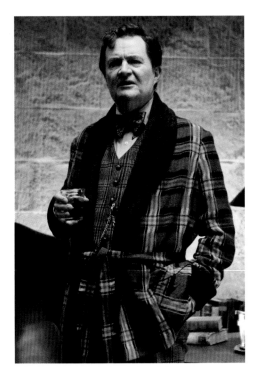

LEFT AND OPPOSITE TOP RIGHT: Slughorn's extensive wardrobe as seen in sketches for *Harry Potter and the Half-Blood Prince*; ABOVE: In a flashback, Slughorn's clothes are in much better shape; OPPOSITE TOP LEFT: Slughorn's "Oxbridge" style robes; OPPOSITE BOTTOM RIGHT: Fabric swatches.

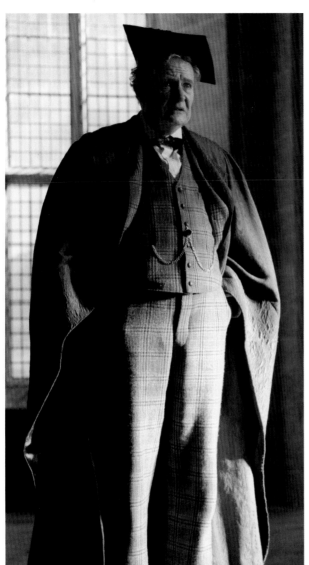

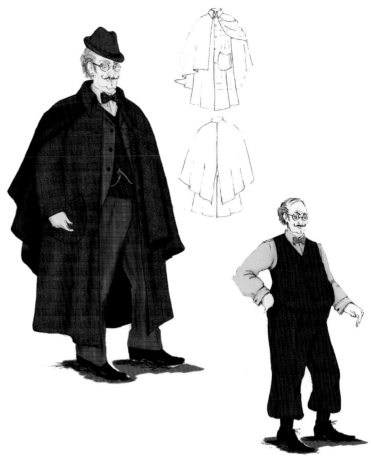

SLUGHORN

"*But that's life, I suppose!
You—you go along and
then suddenly . . . poof.*"

Professor Slughorn, *Harry Potter
and the Half-Blood Prince*

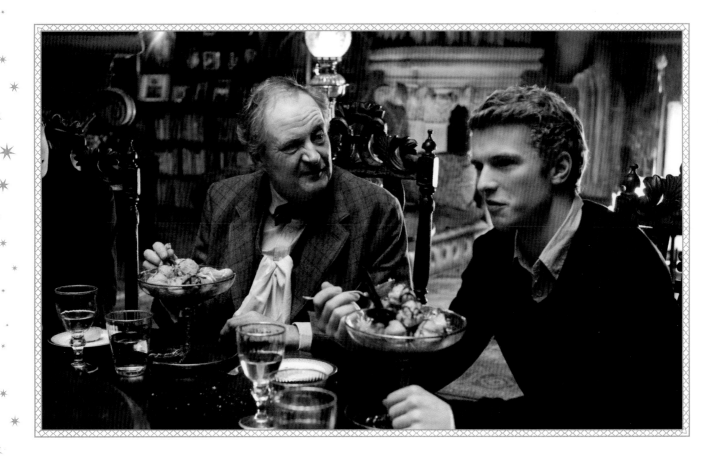

Slughorn's clothes reflect classic English tailoring—three-piece suits, tweeds, and bowties in rusts, browns, and beiges—"but always with a twist. He wears fabric that's a little bit louder, a print that stands out a bit too much." Temime thought of him as "an eccentric dandy," and wanted to show that he enjoys the finer things in life, utilizing velours, damasks, and silks. She gave him Oxbridge-style professor's robes, and a tasseled mortarboard hat. Calling something *Oxbridge*, a word blending the two universities Oxford and Cambridge, suggests a superior intellectual or social status, something she thinks Slughorn endeavors to convey. "He's proud of being an academic," she says, "and it was important to show that." Slughorn also wears an Inverness-style brown-checked cape and a white coat collared and cuffed in fur "from an animal only wizards know."

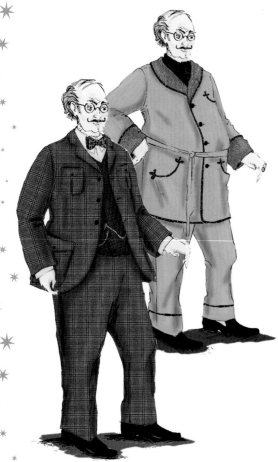

Once Slughorn's wardrobe was assembled, Tim Shanahan's breakdown crew's work began. Slughorn's woolen suits were aged by burning fibers off to thin out areas that logically have the most wear, around the shoulders, cuffs, and pockets. Bright colors were washed out, and a special powder solution was used to give it the appearance of an accumulation of dust that just can't be washed out. How far do outfits get broken down? "When we see through the lining, we stop," says Temime.

ABOVE: Professor Slughorn hosts a party for potential "Slug Club" members in *Harry Potter and the Half-Blood Prince*; LEFT AND OPPOSITE TOP: More costume sketches by Mauricio Carneiro; RIGHT: Detail of Slughorn's robe made of the same material as a chair; OPPOSITE BOTTOM RIGHT: The Potions professor tries to snip off some *Venomous Tentacula* leaves before being interrupted by Harry Potter.

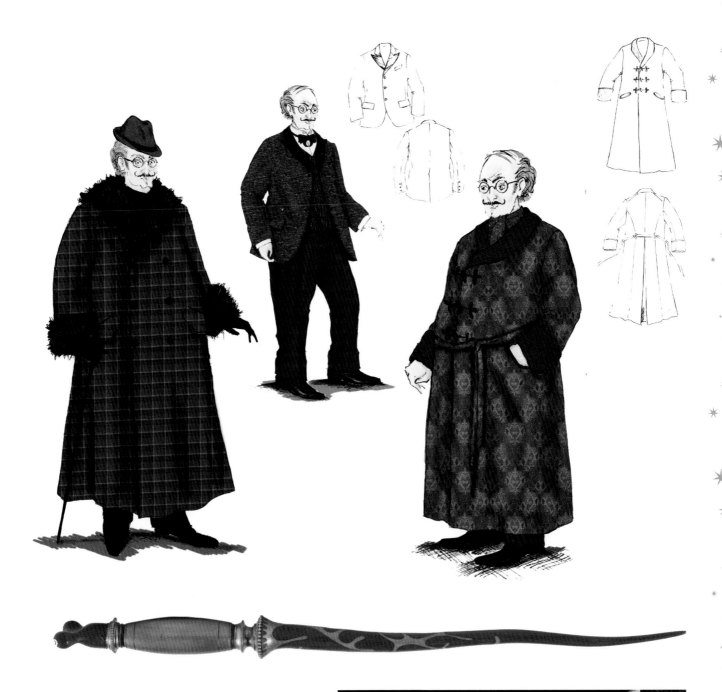

SLUGHORN'S WAND

Concept artist Adam Brockbank designed Horace Slughorn's wand clearly with the professor's name in mind. "It's like a slug, really," Brockbank explains, "so there are two curves in its length to the hilt, and then at the end there's this sort of lump with the two eyes of a snail, done in an amber-looking material." The handle is gun-metal silver, and the shaft has what Brockbank calls a "slug trail design that's silver-inlaid into the wood." The thick casting, with its large amount of metal inlay work, was one of the heaviest wands created for the films.

THE GHOSTS OF HOGWARTS

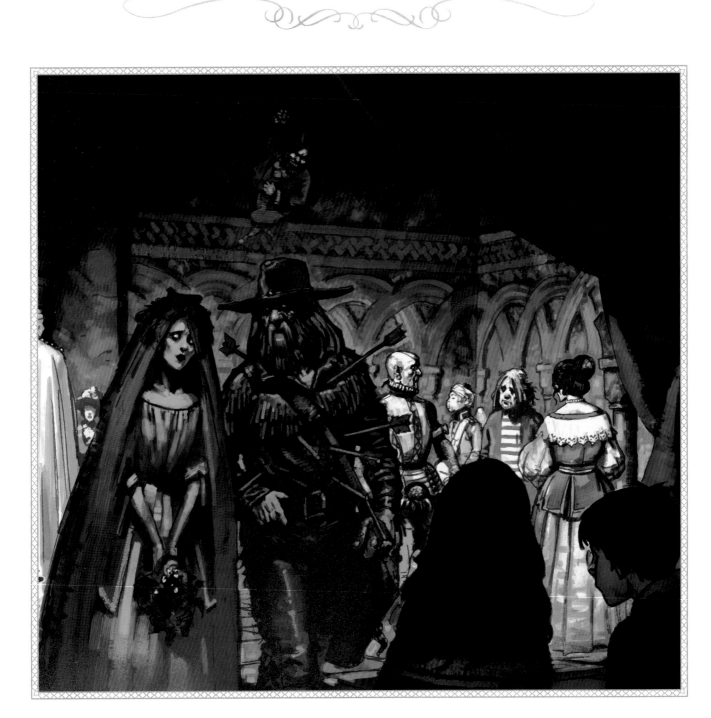

ABOVE: Visual development artwork by Adam Brockbank of the "Deathday" party from *Harry Potter and the Chamber of Secrets* book, which didn't make it into the film; OPPOSITE TOP: Nearly Headless Nick (John Cleese) demonstrates why he is "nearly headless"; OPPOSITE BOTTOM: Continuity shots for *Chamber of Secrets*.

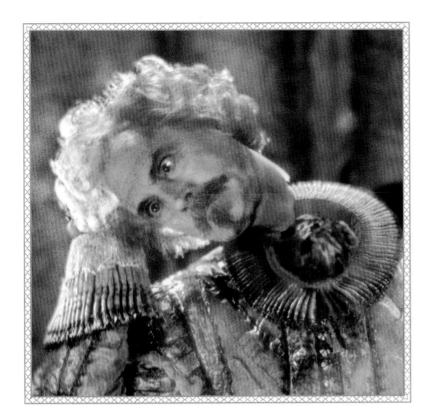

*"I prefer to be called
Sir Nicholas."*

Nearly Headless Nick,
*Harry Potter and the
Sorcerer's Stone*

FIRST APPEARANCE:
Harry Potter and the Sorcerer's Stone

ADDITIONAL APPEARANCES:
Harry Potter and the Chamber of Secrets
Harry Potter and the Order of the Phoenix
(deleted from film)

HOUSE:
Gryffindor

OCCUPATION:
Ghost

SIR NICHOLAS DE MIMSY-PORPINGTON, AKA NEARLY HEADLESS NICK

Judianna Makovsky was glad that the filming of the ghosts of Hogwarts for *Harry Potter and the Sorcerer's Stone* wasn't scheduled until near the very end of the movie. "It took us about nine months to figure out how to do them," she recalls. "They needed to be unusual, and they also needed to work for Robert Legato," the visual effects supervisor for *Harry Potter and the Sorcerer's Stone*. "Trying to find the right material that would work was a very long process." Makovsky alludes to several historical eras for the ghosts of Hogwarts: late Renaissance for the Grey Lady, Baroque/Rococo for the Bloody Baron, and generic monk for the Fat Friar. Sir Nicholas de Mimsy-Porpington, played by actor John Cleese, straddles the border between Elizabethan- and Jacobean-era clothing, wearing a doublet, breeches, and a thin ruff that encircles the "nearly headlessness" of the character. "I don't think I've ever laughed as much during a costume fitting," Makovsky states. "And John Cleese let me go to town. He was willing to wear it all, including some ridiculous pumpkin hose." Makovsky eventually found a mesh fabric for all the ghosts that had copper wire embedded in it so it was moldable and would keep its shape. "I didn't want them to look sheer, like your traditional ghosts with chiffon waving all over the place. We've seen that before. I wanted it to be real clothes from a real period." This worked for Robert Legato, who also found working with John Cleese "a riot. He was only with my team for one day, so we worked hard to get all our jokes right with him." Legato acknowledges that ghosts have been seen on-screen before, "about a million times. So the challenge is how do you shoot a ghost these days and make it better than earlier ones?" In postproduction, the ghosts were given a digital glow and trails of ghostly matter.

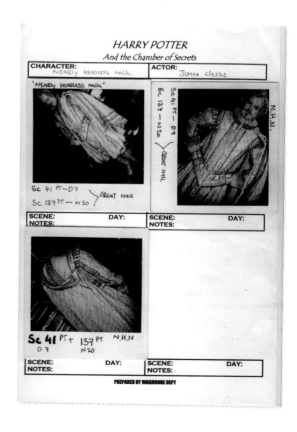

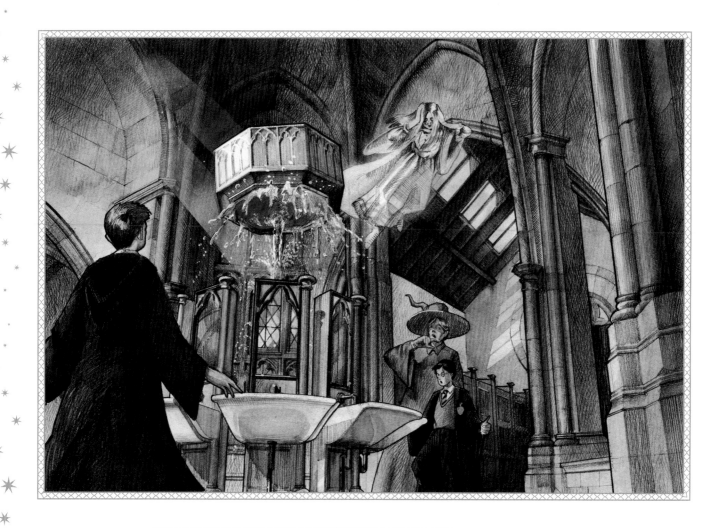

MOANING MYRTLE

Moaning Myrtle, a dead student who haunts the girls' bathroom in *Harry Potter and the Chamber of Secrets* and visits Harry Potter in the Prefects' bathroom in *Harry Potter and the Goblet of Fire*, is played by the distinctively voiced actress Shirley Henderson, who describes Myrtle's sound as "wounded. I did a lot of crying during the scenes and that aided that kind of gurgly quality I was trying to produce—as if she was choking on water all the time." Myrtle's school robes harken back to a time fifty years before present-day events, made in a rough material with smocking near the collar. Any color in her outfit has been desaturated to gray. Henderson was strapped into a harness and flown in front of a green screen to create Myrtle's twists and turns. The filmed Myrtle was then rendered in a digital version. "She dives in and out of toilets, and bursts out of the plumbing system," says Emma Norton, visual effects producer. "Something that obviously had to be done in CGI!"

FIRST APPEARANCE:
Harry Potter and the Chamber of Secrets

ADDITIONAL APPEARANCE:
Harry Potter and the Goblet of Fire

HOUSE:
Ravenclaw

OCCUPATION:
Ghost

LEFT: Shirley Henderson as Moaning Myrtle in a publicity photo for *Harry Potter and the Chamber of Secrets*; TOP: Artwork by Andrew Williamson of Moaning Myrtle hovering above Ron, Harry, and Professor Lockhart as the Chamber of Secrets is opened—not quite how it happened in the film; OPPOSITE: Actor Rik Mayall was cast as the mischievous Peeves in *Harry Potter and the Sorcerer's Stone*, but the ghost never made it past development artwork by Paul Catling.

PEEVES

As happens regrettably when transferring a book to its filmed version, some characters don't make it into the final film. Peeves, a mischievous poltergeist that haunts Hogwarts' halls, was to be played by actor Rik Mayall in *Harry Potter and the Sorcerer's Stone*, but beyond costume sketches, the impish ghost did not manifest on-screen.

> *"If you die down there, you're welcome to share my toilet."*
>
> Moaning Myrtle,
> *Harry Potter and the*
> *Chamber of Secrets*

HELENA RAVENCLAW, AKA THE GREY LADY

The Grey Lady, originally played by Nina Young, is introduced along with the other Hogwarts ghosts at the opening feast in *Harry Potter and the Sorcerer's Stone*; in *Harry Potter and the Chamber of Secrets*, she also appears in a deleted scene. The true identity of Hogwarts' Grey Lady is finally revealed in *Harry Potter and the Deathly Hallows – Part 2* to be Helena Ravenclaw, daughter of the House's founder. Actress Kelly Macdonald, who at one time had been considered to play Tonks, landed the part, which was the last major role to be cast in the Harry Potter film series. Jany Temime chose a simpler, sleeker design than for the original Grey Lady who is more medieval in style. The fitted dress has an embroidered undergown and laced overgown, both with long, draping sleeves.

FIRST APPEARANCE:
Harry Potter and the Sorcerer's Stone

ADDITIONAL APPEARANCES:
Harry Potter and the Chamber of Secrets
Harry Potter and the Deathly Hallows – Part 2

HOUSE:
Ravenclaw

OCCUPATION:
Ghost

"*If you have to ask, you'll never know. If you know, you need only ask . . .*"

Helena Ravenclaw, *Harry Potter and the Deathly Hallows – Part 2*

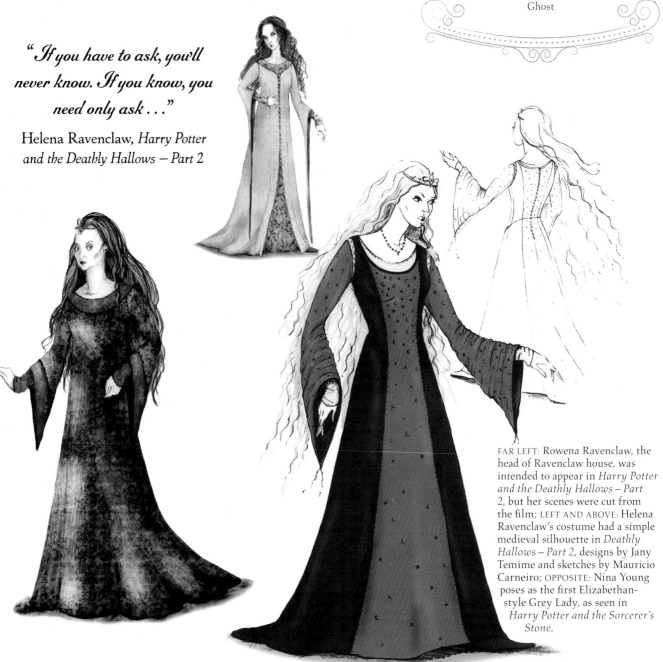

FAR LEFT: Rowena Ravenclaw, the head of Ravenclaw house, was intended to appear in *Harry Potter and the Deathly Hallows – Part 2*, but her scenes were cut from the film; LEFT AND ABOVE: Helena Ravenclaw's costume had a simple medieval silhouette in *Deathly Hallows – Part 2*, designs by Jany Temime and sketches by Mauricio Carneiro; OPPOSITE: Nina Young poses as the first Elizabethan-style Grey Lady, as seen in *Harry Potter and the Sorcerer's Stone*.

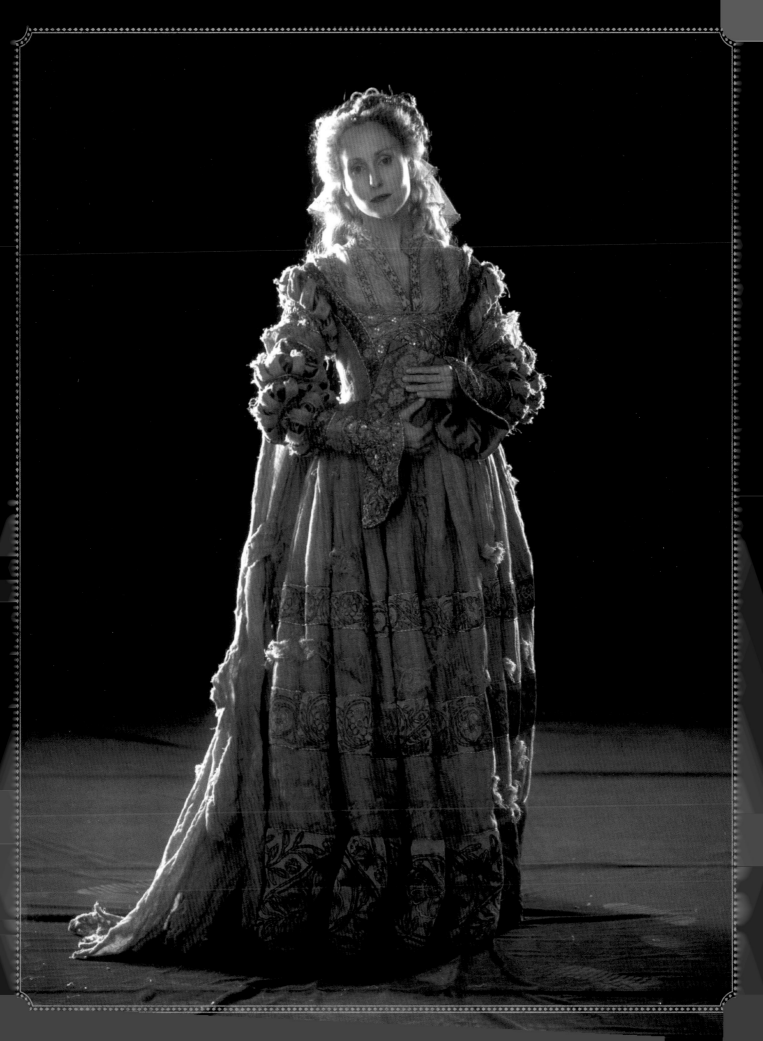

INSIGHT
EDITIONS

PO Box 3088
San Rafael, CA 94912
www.insighteditions.com

Find us on Facebook: www.facebook.com/InsightEditions
Follow us on Twitter: @insighteditions

Library of Congress Cataloging-in-Publication Data available.

ISBN: 978-1-68383-835-7

Publisher: Raoul Goff
President: Kate Jerome
Associate Publisher: Vanessa Lopez
Creative Director: Chrissy Kwasnik
Design Support: Lola Villanueva
Editor: Greg Solano
Managing Editor: Lauren LePera
Senior Production Editor: Rachel Anderson
Production Director/Subsidiary Rights: Lina s Palma
Senior Production Manager: Greg Steffen

Written by Jody Revenson

Insight Editions, in association with Roots of Peace, will plant two trees for each tree used in the manufacturing of this book. Roots of Peace is an internationally renowned humanitarian organization dedicated to eradicating land mines worldwide and converting war-torn lands into productive farms and wildlife habitats. Roots of Peace will plant two million fruit and nut trees in Afghanistan and provide farmers there with the skills and support necessary for sustainable land use.

Manufactured in China by Insight Editions

10 9 8 7 6 5 4 3 2 1